Hawaiian and Other Polynesian Gourds

Other Books by the Same Author

Gourd Growers of the South Seas

Northwest by Sea

New England and the South Seas

Thirty Years of the American Neptune (Editor)

Beyond the Capes

The Polar Rosses

Islands and Empires

Hawaiian and Other Polynesian Gourds

By

Ernest S. Dodge

Director, Peabody Museum of Salem, Massachusetts

Topgallant Publishing Co., Ltd.
Honolulu, Hawaii
1978

Copyright © 1978 by Ernest S. Dodge

All rights reserved. No part of this book may be reproduced or transmitted in any form or by any means, electronic or mechanical including photocopying, recording or by any information storage and retrieval system, without the permission of the publishers.

First revised printing 1978

TOPGALLANT PUBLISHING CO., LTD.
845 Mission Lane
Honolulu, Hawaii 96813

Printed in the United States of America

Library of Congress Cataloging in Publication Information applied for:

Dodge, Ernest S.
Hawaiian and Other Polynesian Gourds

1. Dodge, Ernest S.

ISBN 0-914916-34-3

CONTENTS

List of Illustrations		vii
Acknowledgements		xv
Introduction		xvii
Chapter I.	The Place and the People	1
Chapter II.	The Plant and Its Fruit	11
Chapter III.	Containers	21
Chapter IV.	Musical Instruments	39
Chapter V.	Other Uses of Gourds	53
Chapter VI.	Decoration and Basketry	69
Chapter VII.	Myths, Tales and Proverbs	81
Chapter VIII.	Summary and Conclusions	91
Notes and References		97
Appendix.	Native Names of Gourds	107
Bibliography		117
Index		127
Table of Use Categories		134
Plates		

ILLUSTRATIONS

In order to save space the following abbreviations are used to identify institutional credits.

 B.M. Bernice P. Bishop Museum
 C.M. Canterbury Museum, New Zealand
 D.M. Dominion Museum, New Zealand
 P.M.H. Peabody Museum of Archaeology and Ethnology, Harvard University
 P.M.S. Peabody Museum of Salem
 h. — height; d. — diameter; w. — width

Frontispiece: Growing gourd hagenaria siceravia. [in color]

Plates:

 I Gourd water bottles from the Hawaiian Islands in P.M.S. All of these specimens are decorated by the "Niihau method."
A (E5310. h. 13″) B (E5312. h. 10½″)
C (E22025. h. 12″) D (E5313. h. 10″)
E (E19623. h. 12¼″) F (E18650. h. 13½″)
G (E14024. h. 7½″) H (E5343. h. 13″)
I (E5311. h. 11″) J (E11955. h. 9½″)

 II Hawaiian gourd water bottles. C. and D are decorated by "Pyrogravure method", all others by "Niihau method."
A (B.M. 3938) B (B.M. 3237) C and D (P.M.H. 321)
E (B.M. 6843) F (B.M. 1094) G (B.M. 7750).

 III A and C: two Hawaiian hour-glass shaped water bottles. B Hawaiian cup. D to H: are Hawaiian water bottles used in canoes.

A (P.M.S. E43822) B (P.M.S. E43844) C (P.M.S. E44074).
D (B.M. 3881) E (B.M. 3995) F (B.M. 3877)
G (B.M. 3880) H (B.M. 3879)

IV A Hawaiian water bottle grown compressed in a net (B.M.).
 B Undecorated Hawaiian water bottle in a coconut cord sling (M.B.B. 70).
 C New Zealand water bottle 13″ h; 12″ d. (B.M. 1483).
 D New Zealand water bottle from the Taranaki region. Degenerate ornamentation (C.M.).

V New Zealand water bottles and containers.
 A and B: Good decoration (D.M.).
 C Bottle from Taranaki region (C.M. E96,50).
 D Container in basketry from Taranki region (C.M. E96,50).
 E Bottle of unusual form from Waikato region (C.M. E98,40).

VI Hawaiian cups, one with "pyrogravure decoration."
 A (P.M.S. E16,847). B (P.M.S. E43844).
 D (P.M.H. 315). E. Side of decoration of D.

VII New Zealand preserving gourd, 16″ h; 14″ off ground, legs 22″ high; mouth 3½″ d; funnel 4½ h; 6″ outside d. of mouth (B.M. 1530).

VIII Upper Hawaiian showing method of carrying large containers while traveling.
Lower: Large gourd "whistle" (P.M.S. 54,414).

IX A Hawaiian trunk with "pyrogravure decoration" 21½″ h. (P.M.H. 1280).
 B Detail of decoration on A.

 C Hawaiian basket from which the gourd has been broken, h. 23″; d. 8″ (P.M.S. E5305).
 D Gourd trunk with protective basketry, h. 14″ d. 15″ (P.M.S. E16218).

X A and B: Long gourd boxes (B.M. 3673 and 3674).
 C Gourd container in a net (P.M.S. E19620).
 D Wooden container for fishing equipment with a gourd cover (P.M.S. E14626).

XI A and B: Marquesan household containers (B.M.).
 C Hawaiian box with unusual cover cut from itself (B.M.)
 D Hawaiian gourd in basketry (B.M.)
 E Hawaiian wooden container for fishing equipment with large gourd cover (B.M.)
 F Hawaiian covered container (B.M.)

XII Hawaiian Bowls.
 A and B: Examples of "Niihau method" decoration with dark backgrounds (B.M.).
 C Example of "Niihau method" decorative with light background. Diameter 31 cm. (P.M.H. 37667).
 D "Niihau" method, dark background, probably late designs (P.M.S. E43824).
 E Undecorated bowl (P.M.S. E43826).
 F Bowl with elaborate "Niihau" decoration (B.M. 3729).

XIII Hawaiian Containers
 A and B: Two views of an unidentified container decorated by "pyrogravure method" (P.M.H. 316).
 C and D: Two views of a gourd bowl covered with basket work (P.M.H.).

E Bowl in a suspension net (P.M.S. E21327).

XIV New Zealand bowls
　　　A Ornamented with *mangopare* design. (D.M.).

XV Hawaiian rattles
　　　A and B: Note "pyrogravure method" decoration on B. No feather ornamentation (P.M.S. E43821 and E43820).
　　　C, D and E: Two with feathers, one without (B.M. 868 and 873).
　　　F From Cook's third voyage, Plate 67. Clearly shows feather ornamentation.

XVI Hawaiian spinning rattles and drums.
　　　A Reproduction of an old rattle made for J.S. Emerson (P.M.S. E44228).
　　　B Rattle collected by Rev. Asa Thurston or Lucy Thurston. One end gourd missing (P.M.S. E19773).
　　　C and D: Drums (P.M.H.)

XVII Hawaiian whistles
　　　A (P.M.H. 314).
　　　B and D: (P.M.S. E21329 and E19722).
　　　C Design on bottom of D.
　　　E Design on bottom of A.
　　　F Redrawn from Edge-Partington, First Series, Part II, 386, No. 7.
　　　G and H: Redrawn from Edge-Partington, Second Series, 35, No. 1.

XVIII Hawaiian whistles
　　　A (P.M.H. 431).
　　　B and C: (P.M.S. E19719 and E19721).
　　　D Redrawn from Edge-Partington, Second Series, 1, No. 4.

E (P.M.S. E44018).
F Redrawn from Edge-Partington, Second Series, 32, No. 8.
G Redrawn from Edge-Partington, Second Series, 32, No. 7.
H Redrawn from Emory, *The Island of Lanai*, 118.
I Redrawn from Dalton, Taf. XVI, 8.

XIX Hawaiian whistles in the Bishop Museum
A (951); B (B2740); C (B2741); D (B5930); E (C5931)
F (B6721); G (B6738); H (B6739).

XX Two Hawaiian funnels, an Austral Island water bottle, and an Easter Island drinking cup.
A and B: Redrawn from Brigham, 1908, p. 142. (B.M. 1230, 1231).
C Redrawn from Aitken, 1930, Plate V.
D Redrawn from Métraux, 1940, 195, fig. 15 d.

XXI Hawaiian platter and *kilu*
A and B: Two views of platter. (P.M.H. 37,649).
C Kilu drawn from Edge-Partington, First Series, Part I, p. 60, #14. Diameter 3½".

XXII Hawaiian gourd articles
A Syringe with container for the liquid. (P.M.H. 37,651).
B Toy water bottle (P.M.S. E 19,621).
C *Kilu* with design done by "pyrogravure method." (P.M.S. E 19,627).
D Toy spinning disc. (P.M.H. 37,650).

XXIII Hawaiian gourd articles in the Bishop Museum
A and C: Fish line reels
B *Kilu*
D *Awa* strainer (4142).

E, F, and G: Gourd syringes (4976, 7683, 4978).
H Cow horn syringe (174).

XXIV Hawaiian man wearing gourd mask. From Cook's third voyage, Plate 66.

XXV Painting by Webber of *kahuna* wearing gourd helmets. Courtesy of Miarimis *John Dominis Holt*.

XXVI Designs on bottoms of Hawaiian water bottles in the peabody Museum of Salem.
A (E18,650); B (E5,312); C (E5,343); D (E5,313); E (E22,025).

XXVII Designs on the bottoms of Hawaiian water bottles.
A, B, C and E: (P.M.H. D-2714; 53,569; 312; 48,438).
D (P.M.S. E5311).

XXVIII Designs on bottoms of Hawaiian water bottles.
A and B: (P.M.S. E 5,310 and E 19,623). C (P.M.H. 1254).

XXIX Designs around necks of Hawaiian water bottles.
A, B, E and F: (P.M.S. E 5,310; E 18,650; E 19,623; E 5,313).
C and D: (P.M.H. 312 and D-2938).

XXX Designs on sides of a Hawaiian water bottle.
A, B, C and D: (P.M.S. E 5,311).

XXXI Designs on sides of a Hawaiian water bottle.
A, B, C, and D: (P.M.S. E 5,343).

XXXII Designs on sides of Hawaiian water bottles in the Peabody Museum of Salem.

A and B: (E 19, 623). C and D: (E 5, 310).

XXXIII Designs of Hawaiian gourds
 A Variation in tip of triangle design on water bottle. (P.M.S. E 5,312).
 B "Pyrogravure" on rattle. (P.M.H. D-2941).
 C, D, E and F: "Pyrogravure" design on rattle (M.B.B. 68).

XXXIV Hawaiian gourd designs
 A, B, C and D: Bowl (M.B.B. 71).
 E, F, G and H: Water bottles (P.M.H.).
 I Brick work type design redrawn from Greiner, Plate 19, h.

ACKNOWLEDGEMENTS

I wish to sincerely thank the following people for their generous advice and assistance. Dr. Peter H. Buck and Kenneth P. Emory of the Bernice P. Bishop Museum, Honolulu; W.J. Phillipps, Dominion Museum, Wellington, New Zealand; F.V. Knapp of Nelson, New Zealand; Roger Duff, Canterbury Museum, Christchurch, New Zealand; Dr. Carl Schuster of Cambridge, Massachusetts; Frederick P. Orchard, Miss Guernsey, and others of the staff of the Peabody Museum of Archaeology and Ethnology, Harvard University; have all furnished valuable photographs, specimens, or information. F. Tracy Hubbard, Librarian of the Botanical Museum, Harvard University; Professor Harold St. John, University of Hawaii; and Sterling H. Pool of the Gourd Society of America; have all supplied botanical information. Dr. Frank G. Speck of the University of Pennsylvania has read the manuscript and given me much valuable advice, criticism, and guidance, while Stephen B. Nuttall of Fairhaven, Massachusetts has supplied a good deal of linguistic information. Finally I wish to acknowledge most, the help of my late uncle Edwin T. Brewster of Andover, Massachusetts, whose literary critism enormously improved this manuscript. The above was written in 1943 and regrettably most of those helpful people have now died. Further acknowledgements are now due, however, to Mr. and Mrs. John Dominis Holt, as well as to those authors of material published since that date now added to the Bibliography.

E.S.D. 1978

INTRODUCTION

In 1943 The Gourd Society of America published my book *Gourd Growers of the South Seas: An Introduction to the Study of the Lagenaria Gourd in the Culture of the Polynesians.* The identical book was also published at the same time under the imprint of the Peabody Museum of Salem. Both imprints have been out of print for many years. Before the Gourd Society of America went out of existence a few years ago, however, they reprinted a substantial section of the text, without any illustrations, in their rather obscure bulletin, *Gourd Seed*, in parts during the late 1960's and early 1970's. This periodical has also ceased to exist. While the original copyright had long run out, the Society in terminating its existence, very kindly, as a precaution, turned any right it might still have over to me.

Although this book has long been out of print there has been, ever since, a constant demand for it among ethnologists, botanists, horticulturists, and the garden interested public. It has been also used extensively by the many enthusiasts who grow, mother, develop new varieties, and decorate gourds with love and care as an artistic medium.

Consequently it seemed desirable to publish this present edition. While the book is substantially the same work published in 1943 it is given a new and more accurate title, for the uses of the gourd in the Hawaiian Islands far outnumber those in all the other Polynesian groups. Several paragraphs have been entirely rewritten, some additional material, as well as several new illustrations, have been added and many minor changes have been made to bring it up to date; for an enormous amount of research has been done on the Pacific and its people since the book was originally written. However, these changes have been kept to those that seemed absolutely necessary in the light of new knowledge.

Since I first wrote the book it has been pretty well proven by the

late E.D. Merrill (1954) and in previous writings, as well as Thor Heyerdahl (1952) and others, that *Lagenaria sisceraria* (it was still called *Lagenaria vulgaris* when *Gourd Growers* was first written) is the only plant certainly proven to have girdled the world in distribution through the tropical and temperate areas in pre-Columbian times. Merrill, especially, reiterated at least a dozen times that *Lagenaria* still stands alone as known with certainty to have "pantropic distribution in prehistoric times" in both hemispheres against over 1800 "cultivated species which were never common to nor widely distributed in both hemispheres, until after 1492!"

Merrill and Heyerdahl agree on very little, but the pantropical distribution of *Lagenaria* is one on which they do. They also agree on its place of geographical origin but not on how it got to the Pacific.

Merrill (pp. 255-256) while condeding that no one really knows the geographical origin of *Lagenaria* favors Africa and was persuaded that it was distributed from there to Europe, Asia, Malaysia, Oceania, and thence to America. The plant has been under cultivation since very ancient times and Merrill asserts that it hardly ever occurs as a wild plant.

Heyerdahl points out, however, that the bottle gourd was cultivated in ancient Egypt as early as the third millenium B.C. Thus while agreeing with Merrill and others on its probable African origin he reverses its migration maintaining that it would be much simpler for the gourd to have crossed the Atlantic to America and thence into Polynesia.

He also points out that the gourd was almost certainly in Peru before Polynesians were in their islands and therefore they could not have instroduced the gourd to Peru where, he quotes Bird as saying, that they have been found in graves three to five thousand years old.

However, archaeological work in Polynesia, since both Merrill and Heyerdahl wrote, as been steadily pushing back the antiquity of sites. Nevertheless, not nearly enough yet to overcome Heyerdahl's time argument, but who knows what future archaeological

work will bring. Being sailor minded I find it easier to visualize anything brought by man sailing down wind and with prevailing currents especially when this is combined with shorter distances. But then again good sailors, and there have been many of them over the ages, with adequate craft can go anywhere there is sufficient water and who really knows how advanced ships and navigation were thousands of years ago? However, running true to form from the one agreement made possible by the facts of the case, both men ineluctably come to opposite conclusions as to how the gourd reached Polynesia and Peru. I leave my own ambivalence to the intellectually curious reader.

Distribution problems aside, certain it is that gourds were used as utensils in ancient Egypt, Peru, and elsewhere. They are also still or recently used for many purposes in Africa, for musical instruments in India, for cricket cages in China, for sake bottles in Japan, for mate cups in South America, and for innumerable other functions wherever they grow. Indeed, so widely distributed and diverse are the uses of this equatorially ubiquitous plant, that surely it is one of nature's greatest gifts to mankind.

In Hawaii and indeed other islands, in spite of the voluminous literature, the gourd has not been studied as thoroughly as some other useful plants — especially those providing basic food supplies. But in their Hawaiian-English Dictionary, Pukui and Elbert list over one and a half pages of the word *ipu* with various qualifications — mostly referring to the gourd. It is a general axiom that the more words there are for a plant or an animal in a particular culture the more important the plant or creature is to those people. Scholars of the native arts in Hawaii have, in general, given minimal treatment to the beautifully executed patterns on gourds. It is the wood carving, fascinating in its grotesque human forms, the lovely kapa patterns, and the beautiful featherwork which has primarily attracted the attention of art historians and ethnologists. It may well be that these were the arts of royalty — the chiefs — and that the pyrogravure and engraving on gourds were among the arts of the common people; a way to decorate the utensils they used every day, the essential

containers, the well worn and loved everyday implements — showing the interest and delight mankind often expresses in the artistry and decoration of those functional things so necessary for his very existence. We like to think so.

<div style="text-align: right">Ernest S. Dodge</div>

CHAPTER I
THE PLACE AND THE PEOPLE

The importance of gourds to the Polynesians is no better indicated than by the numerous magical, allegorical, and legendary references to them in the myths and tales of the people.

Arise, O Lono, eat of the sacrificial feast of awa set for you, an abundant feast for you, O Lono!
Provide, O Kea, swine and dogs in abundance! and of land a large territory — for you, O Lono!
Make propitious the cloud-omens! Make proclamation for the building of a prayer-shrine! Peaceful, transparent is the night, night sacred to the gods.
My vine-branch this; and this the fruit on my vine-branch. Thick set with fruit are the shooting branches, a plantation of gourds.
Be fruitful in the heaped up rows! fruit bitter as fishgall.
How many seeds from this gourd, pray, have been planted in this land cleared-by-fire? have been planted and flowered out in Hawaii?
Planted is this seed. It grows; it leafs; it flowers; lo! it fruits — this gourd vine.
The gourd is placed in position; a shapely gourd it is.
Plucked is the gourd; it is cut open.
The core within in cut up and emptied out.
The gourd is this great world; its cover the heavens of Kuakini.
Thrust it into the netting! Attach to it the rainbow for a handle!
Imprision within it the jealousies, the sins the monsters of iniquity!
Within this gourd from the cavern of Mu-a-Iku, calabash of explosive wind-squalls, — till the serene star shines down.
Make haste! lest the calabash sound, and the mountain bird utter its call!
Take hold of it and it crouches; take hold of it and it displays itself at Vavau.

It has been calm and free from disturbances into the night, O Lono, free from the turbulent enmities and bickering of the kahunas, hunters after men.
Arrest them O Lono! arrest the malicious seabirds of Maa-kunewa, with their flashing wings!
Confirm this and make it sacred, wholly sacred, O Lono!
Bind it securely here! The faults will be put in the background; the babbling waters of Waioha will take a second place.[1]

This was the "Prayer of the Gourd" or *Pule Ipu*, recited by a Hawaiian father at the ceremony when his son was taken from the women and installed at the men's eating house. By offering this prayer it is hoped that a boy will be vigorous and become strong like a gourd vine, and it requests that any evil which might befall the boy be shut up in the gourd. To the gods, at this time, a roasted pig was offered. After the pig had been roasted before all the people attending the ceremony, the head was cut off and placed on the alter before the god Lono, at the end of the men's eating house. From the neck of Lono hung a gourd with a wooden bail and into this receptacle the father placed the ear of the roasted pig. Bananas, *awa* root, and *awa* for drinking were set before the image. Then the father offered the bowl of *awa* to Lono and proclaimed "Here is the pig, the coconuts, the *awa*, O ye gods, Ku, Lono, Kane, and Kanaloa, and ye Au-makuas", and then he recited the prayer given above. This done the father sucked the dry *awa*-root (said to be the image drinking it), drank the *awa*, and ate the various meats and vegetables. He then told the spectators, who promptly ate the pork, that the ceremony was over. After this the boy could no longer eat with the women, but henceforth took all his meals in the men's house.[2]

A Polynesian, in the pre-European days, was probably more conscious of the gourd plant than any other human being on earth. The conditioning of a Hawaiian was particularly influenced by the presence of gourds, and countless were the manifestations of this plant upon his life. He was brought up on the myth that the heavens were the top of an enormous gourd, that the earth was its

lower half, and the celestial bodies were the seeds and the pulp thereof. Throughout life he drank his water from gourd bottles, ate his food from gourd bowls, danced to the rhythm of gourd drums, called his lover with the low notes of a gourd whistle, and at last, after death, his bones were perhaps cleaned and kept in an ossuary urn made of a gourd. Before discussing the argicultural methods of raising gourds, their many uses, and the myths and stories about them, it is well to have a glimpse of the environment and the manner of life of the Polynesians.

The oceans of the world are vast and the islands of the world are myriad but no other ocean approaches the enormous dimensions of the Pacific nor does any other possess islands in as many thousands.

Traditionally, for over a century, the peoples of the Pacific were divided by scholars into Australoids, Melanesians, Micronesians, and Polynesians. However, based upon the extensive research that has been done in physical anthropology, biology, linguistics, archaeology, and other fields in the past thirty years, Dr. William Howells in his book *The Pacific Islanders* shows that the old simplistic concept does not begin to answer all the intricate problems concerning these very mixed peoples, their origins, and the many complicated questions relating to them. His book is an excellent summary to serve as a new take off point for scholars. Nevertheless, for the purpose of this book (as was the case with the original edition) I have confined myself to the traditional and familiar Polynesian triangle; with particular emphases on Hawaii where gourds were of unusual importance. To do otherwise would have meant writing an entirely new work, especially when one considers the richness of gourd cultures in parts of Melanesia and the multitude of uses in New Guinea alone, for example.

Within the Polynesian triangle the principal groups of islands are the Hawaiian in the extreme north; the Marquesas somewhat midway between Hawaii and Easter Island; the Society, Cook, and Austral groups centrally located, with the Tuamotu Archipelago and Mangareva to the eastward; Samoa and Tonga to

the westward; and finally New Zealand in the extreme southwest. There are several other groups and many other islands but these are the largest, and at the time of discovery they held the bulk of the population. There are besides those small individual islands which lie outside of Polynesia proper, surrounded by islands inhabited by the racially different Melanesian peoples.

The Polynesian Islands are of two different types. Many are volcanic, mountainous, usually large, and covered with luxuriant tropical or semi-tropical vegetation. The remainder are coral atolls, small and low, with extremely poor soil, and only a small variety of edible plants.

The volcanic or high islands are bountifully supplied with coconut, breadfruit, banana and plantain together with such valuable tuberous plants as taro, yam, turmeric, arrowroot, and sweet potato. The pineapple-like fruit of the pandanus was eaten and its sword-shaped leaves were used for thatching houses, making mats and baskets, and for other useful purposes. The two most important non-edible plants were the paper mulberry for making the native bark cloth or tapa, and the gourd, the utility of which will be discussed in the following chapters. Fowl, dogs, and swine supplied the meat although there were a few exceptions to this distribution; for example, the pig was absent in the Marquesas, the fowl in Mangareva, and both in New Zealand. The meat diet was sometimes supplemented by the flesh of human beings for nearly all Polynesians were, to a greater or lesser degree, cannibalistic. Coral islands, on the other hand, had only the pandanus, coconut, and a coarse, poor variety of taro. Fish to be sure were as plentiful around the low islands as the others but meat, other than man, was lacking. On both sorts of islands in times of famine, various berries, roots, and seaweeds were eaten but these were scorned in normal times. It is easily seen that life was a good deal more elemental on the coral atolls than on the volcanic islands.

Migratory movements of hordes of humanity have been common ever since man has inhabited the earth. Crowded by the pressure of other peoples, allured by richer lands, man has time

and time again taken his women and children, his household goods and animals, and set forth for a new homeland. Sprawling Asia, where mankind reached high levels of development, has also spawned most of the great migrations. Many of these have been overland from Asia to Europe or Africa. A few have been across narrow stretches of water, such as those of the ancestors of the American Indians from Asia across the Bering Strait to Alaska and down into the Americas. But no migrants, not even that rolling tide which for three centuries has flooded North America with Europeans, appeals more to the imagination than the intrepid voyagers who came from southeastern Asia, who worked their way 9,000 miles across the Pacific, settled with in 2,000 miles of the South American coast, and probably, reached the mainland.[3] This movement went on generation after generation, century after century, ever eastward from island to island. The exact location of the homeland of the Polynesians is not known, and the routes they followed into the Pacific are disputed, although evidence now points to a more northerly course through Micronesia rather than through the large Melanesian groups to the south. Buck has ingeniously pointed out that the Polynesians may have arrived in their present home through Micronesia while most of their food plants and domesticated animals came to the region by way of Melanesia.[4]

The supurb seamanship of the Polynesians is proved by the fact that all of the islands in their area that are able to support life are inhabited, or at least have been inhabited in the immediate past. Voyaging such distances toward tiny destinations in dugout canoes hewn with a stone adz never fails to excite the admiration of other peoples who have known the sea. Europeans of a few centuries ago stayed cautiously in sight of land, never venturing out into the Atlantic lest they fall off the edge of the world, though at an earlier date the more pagan Vikings navigated the stormy crossing to North America. But the Polynesian voyager, three centuries before Columbus, solved the problem of overpopulation by building a large canoe, loading it with his friends and relatives, vegetables, a couple of pigs, possibly a dog, a few chickens,

and pushing off in hopes of landfall. On and on he sailed hoping always to find a new and fruitful land, until perhaps a new group would loom over the horizon, it might be two thousand miles from the voyage's beginning. The early explorer did not, of course, know whether he would locate land or not, and the number of those will never be known who sailed on and on over the Pacific never sighting land, until they were drowned in storms or perished of starvation. Besides voyages of exploration, drift voyages also, no doubt, played some part in peopling the islands. Fishing canoes or those on short voyages were occasionally blown off their courses and sometimes landed at other islands many miles distant.

After the Polynesian area was colonized voyages continued between the various island groups. These were apparently deliberate and required no small skill in navigation to reach their objectives. A chief planning a trip of this sort would outfit a large canoe, or possibly several such canoes if the expedition was a large one. Sailing canoes for long voyages were of two sorts. One type had a single large hull with an outrigger: the other and probably more common type for long trips had two large hulls some six feet apart, with a raised platform or deck between the two. If the expedition was for colonizing, the double canoe would carry many more people and equipment for the new settlement, but the outrigger canoe had the advantage of being faster. The usual length of these voyaging canoes was between sixty and eighty feet but the accounts of early observers indicate they sometimes reached a length of over a hundred.

In addition to the equipment of the canoe itself paddles, bailers, spars, and sails made of pandanus mats, each boat was supplied with stocks of prepared foods, water, fowls, and sometimes pigs and dogs. Water was, of course, the most important single item, for it was easy for expert fishermen to obtain some food from the sea. Fish could be eaten raw or cooked over a fireplace built on the big canoes with firewood which was carried along.

The long voyaging between islands reached its peak from the

tenth through the fourteenth centuries, though New Zealand was not settled by Polynesians until 1350, when an expedition of colonists arrived from the Society Islands by way of the Cook group.

The most astonishing achievement of this virile seafaring people is the large proportion of canoes that reached their destinations. This was made possible by the skill and knowledge of the navigators. They possessed no compass or instruments, but they knew the movements of the planets and the courses of the stars, the seasons when various stars and constellations were visible. the habits of the moon, and the positions of the sun north and south of the equator. By these means and with their wide experience with the prevailing winds and ocean currents they left a wake straight from their points of departure to their destinations. So important were these primitive wise men that their personal names are frequently remembered in the legends and stories of outstanding sea journeys that have been handed down by word of mouth for generations.

One of the rather amazing things about Polynesian culture is its general homogeneity over so enormous an area with the centers of population so widely scattered and separated by such long stretches of water. There are, to be sure, cultural groupings within which the islands resemble each other more than they resemble those in other sub-areas. These have been well summed up by Burrows, who shows that the most distinctive cultural area is that of western Polynesia including the Samoa and Tonga groups and the islands of Uvea and Futuna.[5] The many differences which distinguish the west from the central and marginal areas is due mostly to the contact of the west with the comparatively nearby Melanesian group of Fiji. Although the other two principal sub-areas are not as different from each other as they both are from the western, there is distinction enough to place New Zealand, Easter Island, Mangareva, and the Marquesas together in the marginal area; and the Society, Cook, Austral, Tuamotu, and Hawaiian groups, with the island of Rapa together in a central area. Between the central and western regions is an intermediate area

showing affinities with both districts. This includes Niue, Pukapuka, Manihiki, Rakahanga, Tongareva, and the Tokelau and Ellice groups.

Polynesian culture generally is based on a primitive agriculture and fishing economy. No hunting of any consequence was done because of the lack of game animals.

Edged tools for working wood were made of stone, except on some of the coral atolls where shell was used because stone was not available. The Polynesians were clever craftsmen and their well-built canoes, wooden bowls, carved clubs, paddles, and house posts attest their wood working skill. The fine carving on Mangaia adz handles, Raivavae paddles, and clubs from some of the islands was done with sharks' teeth. Most of the designs carved were geometrical but in some regions human and animal figures occur, and New Zealand is distinguished by its elaborate curvilinear patterns. Human figures in the round were carved with local differences, over most of the area excepting western Polynesia.

The religion of the people involved numerous gods, with Tane, Tangaroa, Rongo, and Tu usually outstanding; but there are regional differences in their importance and other important gods appear in addition to numerous minor deities. There are also regional differences in the myths of creation, beliefs concerning the afterworld, and the legends as to the people's ancestral homeland; but the two concepts of *tapu* and *mana* are universal.[6] Kava drinking, both ceremonially and as a beverage, was widespread and was particularly firmly established in the western and central areas.

In general, there were three social classes — the chiefs, the professionals, the commoners; but the privileges and distinctions between these varied widely from group to group.

The great unifying factor in Polynesia is the language. One tongue only is spoken throughout the area although each group and sometimes each island or even part of an island has its dialectical peculiarities. These differences are usually the result of changing or replacing consonents. A consonent may be re-

placed by another letter or by a glottal stop which is represented in writing by the hamzah or inverted comma.

In short, Polynesians were a linguistically homogeneous people in a Neolithic stage of culture, advanced in some respects and retarded, often by ecological limitations, in others. They are scattered over a wide oceanic area and are unusually advanced in seamanship and unwritten literature as well as many other specialized accomplishments.

This necessarily brief, and sketchy picture of the population and the culture involved is preliminary to a detailed account of the importance and distribution of one plant and its fruit in the culture and household economy of the people. The introduction of European dishes, musical instruments, and other technoligically superior objects disrupted the old Polynesian culture so that gourds, along with many other native products, lost their importance and utility. Any treatment of gourds, must then of necessity, depend a good deal on the literature and museum collections. The study must concern itself, for the most part, with the ethnologically immediate past rather than with the present. Archaeologically there is little to be discovered not only because of the fragility of gourds but because archaeological researches in Polynesia have shown few cultural differences from those known historically to ethnologists.

The most important collections available to the author for first hand examination are those of the Peabody Museum of Archaeology and Ethnology at Harvard University, and the Peabody Museum of Salem. Any museums containing general ethnographical collections probably have some Polynesian gourd specimens. The great European collections, however, were beyond reach at the time this book was first written in 1943, and there has not been sufficient opportunity to search them in detail on this subject since. But I have not, in the course of many journeys while doing other research in most of those foreign collections seen anything, in casual observation, notably different from what is herein described. Nevertheless, despite the War, photographs were obtainable from the excellent collections of the Bernice P. Bishop

Museum in Honolulu and the museums of New Zealand. The extensive field studies conducted by the Bishop Museum have recorded scientifically what remains of the old culture on most of the islands.

The discussion of the gourds themselves will center more or less around the Hawaiian Islands as it is from this group that the largest amount of material is available, and it is also here that the gourd found its greatest number of uses.

CHAPTER II
THE PLANT AND ITS FRUIT

Neither the coral islands built up by animal life nor the violently formed volcanic islands possess the necessary means for laying down clay. Only a large river running through continental soil can accomplish this. As clay is therefore excessively scarce in the high islands and absent from coral islands, pottery was lacking throughout Polynesia at the time of European discovery. More recent archaeological work, however, has found some shards, especially in Western Polynesia.

It has been a practice of the past to cite the presence or absence of pottery as one of the criteria for judging the cultural level of a primitive people. When applied to Polynesians, however, it is manifestly shortsighted because of the lack of raw materials to make pottery and the abundant presence of suitable wood for bowls as well as coconuts, calabashes, bamboo, and gourds to make a variety of containers for every purpose.

Since the natives had no clay they made bowls or dishes of wood or in rare cases of stone, or employed gourds, coconuts, or lengths of bamboo suitably prepared for whatever purpose they were used. Thus it comes about that gourds were probably of greater importance as containers in this geographical region than in any other cultural area of similar extent in the world. In competition with gourds the wooden bowls, laboriously carved from a solid block, existed with variations throughout the area.

Gourds are widely distributed and anciently known as useful plants. Fragments of the fruit have been found in Pre-Columbian Peruvian graves and the Prophet Jonah was sheltered from the hot rays of the Iranian sun by a gourd vine. In the Pacific, gourds grow only on volcanic and not on coral islands. Thus the people of the high islands had one more advantage over their brethren. If containers were needed it required only a few months to grow a new supply of gourds, but people dependent on coconuts had to wait many years before new plants bore fruit.[1]

The hard-shelled, light and durable, many-shaped fruits of the white-flowered gourds, *Lagenaria*, are practical natural containers and highly useful for constructing other utensils and objects. This genus is a member of the general family *Cucurbitaceae* which also includes all our squashes, pumpkins, melons and cucumbers. It is widely distributed over most of the tropical and semi-tropical regions of the world both wild and under cultivation. That the plant is supposed to have been originally a native of the old world tropics calls for no comment, but it early came under cultivation and was carried by man to other regions of the world with a suitable climate.

It was probably as an agricultural plant that the gourd worked its way out through Melanesia, was acquired by the Polynesians, and planted on the islands of the Pacific. One theory accounting for its presence in South America credits the far-sailing Polynesians with bringing its seeds to the shores of Peru, probably at the time the sweet potato was taken from its ancestral home in South America westward into Polynesia.

Since the discovery of the islands, Europeans have, of course, introduced all sorts of *Cucurbitaceae*, and now melons, pumpkins, squashes, cucumbers, Luffas and others can be found growing in many localities. Wilder, for instance, lists seven species, not including *Lagenaria*, for the Cook Islands.[2]

Probably only one species, *Lagenaria sisceraria*, formerly *vulgaris*, was native to Polynesia in pre-European times. The theory, held for many years, that the Hawaiian *ipunui* or giant gourd, was a species of *Cucurbita* confined in the Pacific to the Hawaiian Islands only, and native there before the white man came, has now been proved erroneous.[3]

The case of this giant variety of *Lagenaria*, called *ipu nui* by the Hawaiians, and now extinct, is curious. Originally identified by Hillebrand as a *Cucurbita* in 1888, succeeding writers for many years, on the natural history, ethnology, and history of the Hawaiian Islands continued to call it *Cucurbita maxima*. Certain ethnological specimens, notably hula drums and trunks, were usually said to have been made of this species. The writers,

however, were not always in agreement. What was *Cucurbita* to one man was *Lagenaria* to another, with the result that most of the material written about this variety is confusing and useless.[5] This alleged species was said to have been in cultivation at the time Cook discovered the islands and this, with the plant's original botanical identification posed several unsolvable problems, for no native *Cucurbita* existed anywhere else in Polynesia. When my book on Polynesian gourds first appeared, Dr. A.J. Eames of Cornell University was just completing a microscopic study of several pieces of the large thick-shelled *ipu nui* and determined them all as belonging to the common species of *Lagenaria*. At about the same time Dr. Harold St. John of the University of Hawaii was experimenting, unsuccessfully as it turned out, with again breeding the huge gourds. Shortly afterward they published an important paper jointly (see Bibliography) which left no doubt that the giant Hawaiian *ipu nui* was a form of *Lagenaria sisceraria* which has probably been extinct since before the mid nineteenth century although numerous specimens occur in early museum collections. Their conclusions were confirmed by Dr. E.D. Merrill, the famous authority on tropical plants, in his work on *The Botany of Cook's Voyages* (1954, p. 264).

The fruits of *Lagenaria* are highly variable and grow in a wide variety of shapes, sizes, and textures. Many of these varieties have distinctive names and are used for particular purposes. This is especially true in the Hawaiian Islands where Handy lists nearly a dozen different shapes with their native names.[7] Two common Hawaiian varieties were also distinquished as the "bitter gourd" and the "sweet gourd". The bitter gourd is said to have been preferred for utensils because its shell was harder and more impervious to worms.[8]

Other common varieties in the Hawaiian group, which was by far the richest of the Polynesian groups in gourd types, were hourglass, globular, and elongated shapes. Some had excessively thin rinds, while in others the shell was of unusual thickness. Some varieties were apparently localized to single islands, as apparently one thick-shelled kind was confined to Kauai.[9] In

general there is a great deal of ambiguity in the identification of native varieties and various authors' descriptions of them.[10]

A good deal of confusion has been caused by the use of the term "calabash" in referring to Hawaiian containers. The word has not only been used for gourds but is also commonly applied to wooden bowls with the result that one is never sure which material is meant. This error is committed by several authors,[11] so that when the word "calabash" appears one never knows whether it means a wooden bowl, a large *ipu nui*, an ordinary gourd, or simply some sort of container. Because of this confusion it would probably be better in technical writing to restrict the term "calabash" to the fruit of the calabash tree, *Crescentia cujete*. I have therefore avoided using the term in reference to gourds except when enclosed in quotation marks.

The fullest data on the cultivation, and horticultural and agricultural methods of growing gourds is from the Hawaiian Islands and New Zealand in the extreme north and south of Polynesia. For these two regions the accounts of Handy and Best contain most of the information recorded.[12]

In the Hawaiian Islands certain very sunny localities with moderate rainfalls were best suited for gourd growing. Hot, low land near the shores on leeward and southerly sides of the islands usually filled the requirements. The island of Niihau was particularly famous for its gourds though certain localities on other islands were also favoured.[13] The natives of a good gourd growing region might exchange their products for the superior produce of a different kind from another locality, thus gourds were articles of trade as well as useful in household economy.

Gourds were planted at the beginning of the rainy season and matured to full size during the hot dry summer in about six months. Handy mentions that iron tools were favoured for planting gourds in one neighborhood because the shell would then be hard.[14] This, of course, would have been in post-European times when iron had replaced many of the native wood, stone, or shell tools.

Handy also has a good description of the ideal method of

sowing the seed. "It was believed that a pot-bellied man should plant gourds, and that before he planted he should eat a large meal, so that his gourds would fill out like his stomach (*opu*). He should stoop as he carried his seed, holding his arms bowed out as though embracing a huge *ipu*, struggle along and puff. Coming to the hole he had dug and dropping the seed suddenly with an outward motion of the hands, palms up (not twisting and turning down the palms, which would make the gourd crooked and shriveled), he should say:

He ipu nui!	A huge *ipu*
O hiki ku mauna,	Growing like a mountain
O hiki kua,	To be carried on the back
Nui maoli keia ipu!	Really huge is this gourd

Encouraged by this little drama, the plant was certain to produce huge fruit. This rite was doubtless addressed only to the giant gourd seed (*ipu nui*)."[15]

While the gourd vine was growing, people were careful not to walk so as to cast a shadow on the flower. Handy says this was because the gourd was the body of Lono, the rain god, while Roberts thinks it was because the shadow caused the flowers to wither.[16] Handy also writes that for the same reason gourds were never planted near the house because they should never be touched by a menstruating woman.[17]

While the fruit was growing it was carefully cared for. Handled only after dark or before dawn, the gourds were set so they would not become deformed in any way. The grass or dirt beneath them was smoothed out, stones cleared away, and the fruit placed upright. Sometimes a wooden support of three sticks was made and the gourd suspended between them while a sort of pad of leaves or grass was prepared underneath.[18] By these methods the fruit would be full and round and the necks straight.

Captain Cook said that some of the forms were obtained by bandaging the fruit during the growing season, but Handy had native informants who denied this.[19] It is possible, however, that

methods had somewhat changed between the discovery of the
islands and the memory of people now living. There is one curious
specimen in the Bishop Museum (Plate IV, A) of a gourd water
bottle which was obviously grown inside a net. The neck of this
unique specimen is normal but the lower bulbous portion was
enclosed in a net before the fruit reached full maturity with the
result that round protuberances were formed where the fruit was
forced through the meshes. This is reminiscent of the molded
gourd Chinese cricket cages grown in clay molds.[19A]

Natural enemies of the gourd during its growing period included a black scale, insect stings and aphids. There was also a
kind of blight which shrivelled the vines. When this occurred,
Handy relates that the Kau people, with the exception of one
family, pulled up their vines and burned them. The one family
was related to Lono, and they buried their vines instead.[20]
Gourds might also receive malicious treatment from a jealous
neighbor or they might be stolen. If, however, the owner gave a
gourd the name of an ancestor it would not be molested.[21]

The gathering of gourds took place when the stems of the fruits
had withered.

In New Zealand, where the gourd was no doubt introduced by
Polynesian immigrants, it was cultivated extensively. Legend
says it was one of the earliest of introduced plants as the seeds
could be wrapped up and carried, while with taro or sweet
potatoes the entire tuber must be taken along. For the best growth
a damp, rich soil with plenty of sun was required and this was
often found in or near the taro plantings or near the edges of the
woods or thickets.[22] The plant did not flourish in the high,
mountainous localities. The South Island was too cold for its
successful growth and its use as containers was largely replaced
by those made of the large fronds of a local species of seaweed.[23]

Seeds were treated to promote quicker germination and Best
cites Colenso, saying that before sowing seeds were wrapped in
dry fern fronds and soaked in running water for a few days.[24] He
also says that before planting seeds were soaked in water and then
embedded in a mixture of soil and decayed wood in a basket. The

contents of the basket were then covered with leaves or grass and the basket buried in the warm earth near a fire until the seed sprouted. When this took place they were removed from the basket and planted.[25] The natives of the East Coast sometimes planted the seeds in a seed bed and then transplanted the seedlings.[26] Gourd seeds were always planted during the 16th or Turu, and 17th or Rakau-nui, days of the moon's age, that is to say just after the full.

Best describes the ceremonial method of planting. "The planter takes a seed in each hand, each held between thumb and finger, and, facing the east, he raises his arms until his hands meet, but bringing them upward far apart so as to almost describe a circle, in order that the gourds may grow into a similar large size. As the right arm is so brought up, it is bent at the elbow, so that the gourds may acquire that form and grow with the curved shank so desirable in gourds used as water vessels.[27]" When the arms are lowered he places the seeds in a prepared hole. While the planter was working he repeated:

O Pu-te-hue!
May you increase in growth,
May your fruit grow round on your arms,
May your fruit shape to great size.[28]

White collected another chant repeated by a planter of gourd seed:

What is my seed?
My seed is a Turu, [16th]
My seed is a Rakau-nui [17th]
Rest there [on the first seed mound]
O my sacred pole,
Lie there with your children
Bear fruit like [the eggs of] the kiwi
Bear fruit like [the eggs of] the moho.

Provide fruit to be poured
On the runners of Pu-te-hue.[29]

By repeating these chants while sowing the seed it was hoped that a bountiful crop would be insured.

There may have been two types of planting. Cook and other early visitors noted that gourds were planted in hollows or ditches similar to the method of planting cucumbers in England.[30] Native informants, however, told Best that the seeds were planted in little heaps of earth.[31] On the East Coast they were transplanted from a seed bed to mounds with four seedlings in each.[32]

After the appearance of the fourth leaves on the young plant, cultivation commenced. The earth was loosened; and when the young runners began to turn toward the ground, the soil was heaped round the plants and pressed down. Wood ashes were worked around the plants as fertilizer.[33]

The Maori fertilized the female blossoms of the gourd plant by hand, as Europeans do pumpkins.[34]

The fruit was carefully cared for during the growing season, particularly if containers were desired. If a large container was wanted the ends of the runners were pinched off, some of the young fruit removed, and the ground under the remaining fruit smoothed off and covered with sand. A gourd intended for preserved birds was often stood on end and kept in position by pegs to insure its uniform growth.[35] Sometimes when the gourd was about the size of an orange it was carefully lifted from the ground and dry grass put under it and kept there until it reached maturity.[36]

A ceremony that was supposed to make the plants yield profusely was performed by picking the first young fruit of the season and cooking it. While it was cooking a branch of *karamu* shrub was placed in the oven and the person doing the cooking made movements over the oven with her hands as though she were using a digging stick.[37]

It is said that gourds were shaped in dumbbell like form by tying a band of flax round the middle during the growing sea-

son.[38] This was also done in Japan where gourds were grown for water or sake bottles.

If the gourds were for food they were gathered young and eaten but those to be used as containers were left to mature so that the shell would be hard and durable.

For Easter Island, Métraux lists gourds among those plants cultivated by natives,[39] but he also says it was growing wild in abundance fifty years ago although today it has disappeared. Any knowledge of native methods of cultivation is now probably lost. In 1780 LaPerouse mentioned sea water offered to him in gourds, but he also wrote that his gardener left gourd seed among others, for the natives to cultivate. Possibly this referred to cucumber or squash of some kind.[40] Both Gonzalez in 1770 and Cook in 1774 saw gourds growing in the fields.[41]

Methods of cleaning and preparing gourds for use in Hawaii varied with the variety of gourd and the type of container being made. For making bowls, cups, or other wide-mouthed containers it was a simple matter to cut off the top and clean out the pulp. If the fruit was of the "sweet" variety this could be done and the container used immediately.[42]

If the "bitter gourd" was being prepared, however, the process was a bit more elaborate. The gourd was first cleaned out as completely as possible and the shell was then allowed to dry. When the rind was thoroughly hardened the remaining soft material was scraped out with pumice or coral, and the gourd then filled with water which was left in it until all the bitterness had vanished.[43] A variant of this process consisted of filling the gourd with sea water which was changed daily for ten days. This softened the tough flesh which was scraped out, and eliminated the acidity.[44]

Extracting the pulp from any gourd to be used as a water bottle was more difficult because of the small opening. Water was poured in to hasten the decaying process. When the pulp was well rotted it was shaken out and stones and sand shaken around inside until all the soft parts were eliminated and the hard shell

was clean.[45] After cleaning, water was left standing in it until it became sweet.[46]

The New Zealand method was somewhat different. After the gourds were picked they were either dried before a fire, by the sun, or buried in sandy or gravelly soil. This assisted the pulp to decay and the inside was then cleaned with gravel. After cleaning, the gourd was hung in the smoke of a fire to harden.[47]

Although nothing has ever been recorded, presumably the methods of preparation in other Polynesian islands did not differ materially from those described.

The staple food of the Maori of New Zealand was the sweet potato but one of the important supplementary foods was the gourd which was eaten in particularly large quantities during the summer.[48] Only the young fruit was used as food. It was always baked in an earth oven and then eaten both hot and cold.[49] Elsewhere in Polynesia gourds were apparently not eaten except possibly in times of famine. The bitter variety of the Hawaiian Islands was not edible at all but its juice mixed with warm sea water, or its seeds and pulp was taken as a strong cathartic administered by the kahuna.[50] So far as is known this practice was unknown on other island groups on Polynesia.

CHAPTER III
CONTAINERS

The most obvious use for a gourd is to have it hold something. Gourds as containers, are therefore almost universal wherever they are grown. Speck discusses the possibility of gourd containers as the antecedents of pottery among some of the Southeastern Indians;[1] while Brigham,[2] basing his conclusions on linguistic evidence,[3] thinks it probable that gourd containers preceded wooden bowls and dishes in the Hawaiian Islands.

Although a number of different categories for containers have been set up in the following pages and tabulated in the accompanying table, it is impossible to indicate by these methods all different uses for the same container or like uses for different forms. Obviously one could enumerate all the uses of an ordinary American cooking bowl, with all the multitude of foods and ingredients that it may hold at various periods of its career. Such a list, however, would prove little. Yet if the same bowl is put over a child's head for a guide in cutting its hair, that use is so different from the usual that it should be recorded. There is the same difficulty in dealing with Polynesian gourd bowls. This owner possessed normal common sense, and if a given object seemed useful for a given purpose it was likely to be so employed, though this might be far from its intended original use.

Gourd containers were very widely used in the Hawaiian Islands and on Easter Island, and somewhat less in New Zealand, while in the Marquesas, Society, Cook and Austral groups they were distinctly secondary to other containers. In Samoa and Tonga a single use only, for holding coconut oil, is recorded.

In Hawaii and Easter Island gourds served not only as the nearly universal water bottles, but also as the principal food dishes and for keeping all kinds of chattels and equipment. It is in these two localities that most of the confusion about uses of forms arises so as each item is discussed an attempt will be made to indicate and explain the complications of each type. Concerning

New Zealand, Best tells us that "gourd vessels were much used",[4] but how or for what is not clear although certain types are well known. While we know that coconut shell and gourd containers were hung from the beams of Marquesan homes, we are not told whether they were used for other things than food.[5] We do know that although they had to compete with coconut shells and lengths of bamboo,[6] gourds were made into both necked bottles and neckless containers called *hue*.[7] Although existing specimens of *hue* are less than a foot in diameter, Linton found large wooden tops in burial caves which suggest that much larger vessels of this type were formerly used.[8] In Easter Island, gourds called *hipu*, were the only containers used by the natives.[9] Métraux says that round gourds were used as containers for small things[10] — presumably as a sort of catch-all. Gourds are preferred over coconuts in the Australs, and were used for various dishes, food containers, liquid containers, and other purposes,[11] while in western Polynesia the large coconuts and lengths of bamboo are preferred.

1 – 4 Water bottles

The use of gourds as water bottles is nearly universal wherever gourds are found. Light, practical and easily replaced, they are admirable suited for this purpose. In Polynesia generally, however, gourds as liquid containers divided honors with large coconuts and lengths of bamboo. In most of the groups where gourds were so used, one simple type of bottle was made. These are listed in the first column of Table I — partly for convenience and partly because in general they most nearly correspond with that Hawaiian type indicated in Plates I, II, IVB.

The use of gourd water bottles in the Hawaiian Islands is well known, literary references are numerous, and specimens of them in collections are not uncommon. The absolute typing of different kinds of Hawaiian gourd water bottles, however, is not easily done, partly because of the natural tendency of a gourd to grow in quite a diversity of shapes, and partly because it was such a universal and common use for gourds among the natives that

individual taste and preference of type probably came strongly into play.

These various types of gourd water bottles, described in detail further on, were among the native Hawaiians' most important vessels. The entire water supply of a household was kept in them, they were used for carrying water from streams and springs, for transporting salt water, and they also contained the water supply of fishermen and voyagers. Bishop gives an interesting account of the use of gourd water bottles in the Hawaiian Islands about 1836 which indicates their importance at that time.

"If in a dry season, water was lacking on the open ground, it could always be found higher up on the mountain in such cases. Twice a week one of our ohuas or native dependents went up the mountain with two huewai, or calabash bottles, suspended by nets from the ends of his mamaki or yoke, similar to those used by Chinese vegetable venders. These he filled with sweet water and brought home having first covered the bottles with fresh ferns, to attest his having been well inland. The contents of the two bottles filled a five gallon demijohn twice a week."[12]

After the bottle was filled, a terebra shell, cachelot tooth, or folded palm or pandanus leaf was used as a stopper.[13] It is said that gourd bottles were occasionally covered with basket work but I have never seen any specimen so protected.[14] Some of the water gourds must have been very large as Ellis mentions them capable of holding four or five gallons.[15]

The Hawaiian gourd water bottles can be divided broadly into three types; (1) those for use about the household, [Plates I,II,III A to C]. (2) those for use at sea aboard canoes, [Plate III, D to G] and (3) those taken into the field or to work by men and women [Plate I, G] The common native name for a water bottle was *huewai*[16] but *ipu wai*[17] was apparently also used. A particular type of gourd bottle used only for carrying water in canoes was called *olowai*.[18] A gourd water bottle [Plate III, A and C] of the hourglass shape was called *huewai pueo*.[19]

The household water bottles were of two forms, (a) the large globular-shaped with a long thin neck [Plate I, II] and (b) the

hourglass shaped [Plate III, A and C]. Which of these two types was the commoner I do not know; but judging from the known ages of specimens available, the (a) type is commoner among the older specimens while the (b) type predominates among the more recent. The *huewai pueo* had the advantage in that it needed only a cord rather than a net for its suspension.[20]

Specimens of the globular-shaped bottles examined included eight old examples in the Salem Museum,[21] nine at Harvard;[22] and one in Mrs. Bishop's collection now at Salem.[23] Of these fifteen were decorated and three were plain. Bottles of this type vary considerably in form. One common type has a straight, slender, parallel-sided neck from which the base bulges sharply [Plate II, F]; another is more pear-shaped, the neck gradually increasing in size until the full diameter of the gourd is attained [Plate II, A]. A variant of this has a bulge the size of an apple, and thus approaches the hourglass-shape [Plates I, B and I]. An unusual water gourd [Plate IV, A] in the Bishop Museum has been compressed in a net while growing and is an unusual form as the molding creates quite a decorative effect.[24]

One specimen [Plate I, G,] very much smaller than any of the others, is called a "drinking gourd" by J.S. Emerson, who describes it as "a small *hue wai*, five inches in diameter, to be suspended by a string through the hole near the aperture. Such water gourds as this would be carried by a woman to her place for beating kapa or by a man to his work in the field. This old specimen was found by myself in the burial cave of Kanupa."[25] This would really form a distinct category from the other larger bottles used for storing water in the household. Its small size makes it easily carried, but at the same time it would hold a supply of water for one person for several hours.

The household water bottles of the hourglass-shape also had their sub-types. One specimen is made of a gourd with the stem end, which is slightly curved, cut off for the mouth,[26] and is slung in a net (*koko*) of twisted coconut fiber cord. Another [Plate III, A] is much the same but the stem is straighter and the bottle has been painted red.[27] It is slung in a non-typical net of European cord.

Salem specimen E44074 [Plate III, C] has the documentary evidence that it comes from Lahaina on Maui, perhaps indicating that it is a type preferred on that island.[28] The upper part of this gourd is considerably bent to one side from the vertical axis of the much larger lower bulge and the stem is strongly curved. The outstanding peculiarity of this specimen, however, is that the mouth of the bottle is cut in the side of the gourd near the top of the lower bulge, in contrast to all other specimens I have seen where the obvious method of cutting off or puncturing the stem has always been used. Whether or not this practice is confined to Maui has not been determined. This bottle is slung by a simple sennit braid looped around its constricted waist.

The canoe water carriers [Plate III, D to G] termed *olowai* are very different in appearance from the types previously described. Five specimens in the Bishop Museum show that these bottles were made from long thin gourds, the mouth formed by cutting off the end of the stem, which itself has sufficient curve to prevent water from running out of the gourd when it is placed on its side. All have slings for hanging under a thwart of a canoe.[29] The specimens average about fourteen to eighteen inches in length.

Gourds were used as water containers extensively in New Zealand, but neither here nor elsewhere in Polynesia were there the variety of forms and the elaborate decoration characteristic of the Hawaiian Islands. Two forms of New Zealand water gourds have been noted. One type [Plate V, A and C], illustrated by two specimens, is made of a tear-drop shaped gourd. The mouth is formed by cutting a small opening in the side of the gourd immediately below the stem, which is left intact.[30] Another form figured by Hamilton, is made from a similarly shaped gourd but has a much larger mouth formed by cutting off the entire top.[31] This container is slung in a netting with a handle for suspension. The only comment on the specimen is the caption calling it "a calabash for holding water." The material used for the netting, and the size and location of the specimen are unknown.

The common Maori name of a gourd for holding water was *taha* but *ipu* meaning a calabash with a small opening was also used.[32]

A tradition also exists which mentions a container called *taha rakau*. This was a wooden vessel, shaped like a gourd, made in two halves, hollowed out and lashed together with joints sealed by a vegetable gum.[33] Here we have the derivation of a wooden vessel from a known gourd form.

In the Marquesas, gourds called *hue* and large lengths of bamboo called *kohe* were used for storing water,[34] but small bottles were either of gourds or coconuts.[35] Outside of this meagre information, little is known about Marquesan gourd bottles. It is said, however, that gourd water bottles, along with bowls holding food, were hung from branches near the resting places of the dead.[36]

On Easter Island, where gourds flourished and furnished the only containers, their use as water bottles was well known.[37] The gourds so used were of an elongated form.[38] Their native name was *hue vai* and the opening, naturally enough was at the small end.[39]

In the Society Islands gourds have apparently not been used as water containers in recent years as the only reference to such use is the following passage from a Tahitian legend: "Bamboos and gourds were filled with water and stowed away on board, . . ."[40] That gourds were once extensively used for water bottles in Tahiti is indicated by Ellis' statement that "drink is contained in calabashes, which are much larger than any I ever saw used for the same purpose in the Sandwich Islands, but destitute of ornament. They are kept in nets of cinet and suspended from some part of the dwelling."[41] Probably lengths of bamboo were of much greater importance for this use in these islands.

For the Cook Islands, the principal information is from Aitutaki where gourds were the most important water containers. Buck's statement that a gourd so used "had a hole cut into it near the stalk end"[42] indicates a close resemblance to one of the New Zealand forms (Cf. p. 21). The native name *taha* of a gourd so used is also similar to one of the New Zealand names, although the local gourd plant itself was called *hue kava*.[43]

Information from the Austral Islands is also scanty. Based on a

small collection of mythological material from this group, Aitken found that in the ancient culture of Tubuai gourds were used as containers for sea water and coconut bottles for fresh water.[44] He also figures a specimen of such a vessel in a sling of netted sennit.[45]

Gourds are unknown as water containers in Samoa and Tonga at the present time buy Handy in his "Polynesian Religion" (pp. 226-227) refers to a Samoan water gourd.

5 – Cups

Cups, usually made from other material than gourds, were used for drinking both water and kava in various parts of Polynesia.

Specimens of cups from the Hawaiian Islands are commonly made of coconut shell but gourds of the proper size, sometimes called cups and sometimes small bowls, occur occasionally. One decorated and two undecorated specimens of different shapes were examined, one [Plate VI, B] is three and one quarter inches in diameter and three inches deep.[46] It is made of a comparatively thick shelled gourd and curves considerably toward the mouth. Another [Plate VI, A] is shallower, greater in diameter, and thinner shelled, three and three quarter inches in diameter and 2 inches deep.[47] The third [Plate VI, D] is similar in form but is elaborately decorated with pyrogravure designs.[48] It is three and three quarters inches across the mouth and two and one half inches deep. These cups may have been used for either water or kava, but only one specimen thought to be for kava has been found at Kahoolawe (Hawaiian Islands). "This gourd measured 7.7 inches in length, was cut longitudinally, slightly greater than the median. At the apex a small spout has been formed. The base of this vessel, which is thought to be an *awa* drinking cup (*apu awa*), is now broken."[49]

Cups were not used by the Maori of New Zealand who drank directly from the stream, gourd water bottle, or their hands.[50]

For the Marquesas, Christian in describing the native household implements mentions "two or three calabashes *(Hue)* for

drinking vessels."[51] But although he may have been referring to cups I think it is more probable, as this is his only reference to gourds, that he was talking about the commoner water bottles. No doubt coconuts were the common cups as indicated by Brown.[52]

Metraux figures a gourd cup from Easter Island which he describes as a "calabash (*ipu*) for drinking water, 72 mm. high, 85 mm. wide."[53]

6 – Oil containers

So far as is known, gourds for holding coconut oil were used only in the Society, Samoa, and Tonga Islands, and New Zealand. For the Society group Henry writes: "The *aroro* is a small spherical gourd, the size of a medium-sized orange, and has been used by Tahitians exclusively as containers of coconut oil."[54] There are also two references to these vessels in one of the legends recounted by the same author.[55]

In Samoa the gourds for coconut oil were called *fangu* but are no longer used.[56]

The only information for Tonga is contained in a tale which in three instances mentions gourds for oil, also called *fangu*.[57]

Two brief sentences by Best that "perfumed oils and rouge" were kept in small gourds and that "exquisites used them to contain the scented oil used for toilet purposes" are all the knowledge we have for this use in New Zealand.[58]

7-8 Bowls, dishes, and food containers

Various kinds of gourd utensils used about the household are grouped here as they were used for a variety of purposes and it is very difficult to distinguish the different types. A broad classification can be made by dividing the vessels into open and covered containers. The open containers consist of bowls of assorted shapes and sizes while the covered containers are more diversified in type.

The general name for all bowls and dishes of the Hawaiians is *ipu* irrespective of whether they are made from gourds, wood, or coconut shell.[59] As ipu also is the name for the gourd plant, the

supposition is that the natural container preceded its manufactured counterpart. Gourd bowls were used for *poi*, fish,[60] and any food that it seemed desirable to put into them. The large gourds for storing *poi* were very big, while bowls used during a meal were small. The extensive and varied use of these natural dishes makes any real hard and fast rules for their utility impossible.

For traveling, before the 1860's, one of two large trunks carried by slings from a pole [Plate VIII] was used to contain food, while its gourd cover served as a dish.[61] Decorated bowls made of gourds were called *umeke pawehe*[62] or *ipu pawehe*[63] as distinguished from plain varieties or *ipu pohue*. Lawrence, probably seeing the *poi* containers, comments that some of the food containers were made of large gourds.[64] Stubbs says that gourds served as receiving vessels in the household.[65]

Ipu for holding food were considered part of the wealth of a Hawaiian family. Those used for the specialized purposes had distinguishing names. If they were for poi or other vegetable foods they were called *umeke*, bowls for soup, cooked or raw meat, or fish with sauces or gravies were *ipu-kai*.[66] Food gourds were of sufficient economic importance to figure prominently in Hawaiian ceremonies. In one known as "The Bringing of Gifts" they were used as containers for poi and sea-urchins.[67] When the property, including food containers, of a chief who possessed a certain kind of tabo called *kapu-a-noho*, was carried along the road any person who did not prostrate himself was put to death in accordance with the law of the taboo relative to the chiefs.[68] A full food bowl was a sign of abundance and was called *ipu ka eo,* or *umeke ka eo* while an empty bowl was *umeke papa ole,* i.e., an unripe gourd.[69]

Of the seven bowls and numerous photographs examined only a few were decorated [Plate XII]; plain bowls being by far the most numerous. They range in size from five to ten inches in diameter. Two of the undecorated bowls were collected on the island of Oahu.[70] Gourd bowls were occasionally covered with basketry. One of this type [Plate VIII, C,D] in the Harvard collection is eight inches in diameter and four and one half inches high.[71]

Covered food containers were used for storing *poi* and other food. Apparently the uncommonly large gourd containers used for trunks when traveling were used for storing *poi* at times.[72] A very much smaller container [Plate X,C] of similar form to the large trunks is in the Salem collection and has a well documented history. It was acquired by the Museum in the Goodale collection (made by the Reverend and Mrs. Asa Thurston) and a contemporary note found inside it states that "this was a small *poi* calabash" and that they were sometimes grown to immense size. Here too is documentary evidence that the large gourd trunks served a dual purpose. The writer of the note goes on to say: "Some of the same shape as this, would hold one or two gallons of Poi when used as food receptacles. Sometimes enclosed in nets, with their neat covers securely bound on with cords fastened in the side, these calabashes made convenient traveling trunks for clothing swung on a pole and borne on men's shoulders."

A small gourd covered container of unusual form is figured and described by Dalton.[73] The specimen, now in the British Museum, was collected at Hawaii on Vancouver's voyage (1790-1795). The vessel is made of a pear-shaped gourd, similar to some of those used for keeping fishing equipment, and in fact this may have been its original use. It is enclosed in a net which has large meshes at the bottom and small meshes at the top around the neck of the gourd.

In New Zealand gourds for bowls and other food containers were used more commonly in the northern than in the southern part of the islands the extreme southern climate being too rigorous for the plant. The special containers used for birds will be given a section by themselves.

The finest gourd vessels were those used for holding the food of chiefs, called *ipu-whakairo*.[74] These, both bowls and water bottles, were covered with elaborate designs incised upon the outer surface. A specimen [Plate XIV, B] of such a carved bowl in the Dominion Museum is formed by cutting off the top of the fruit. A similarly carved specimen [Plate XIV, A] in the Bishop Museum, however, is formed by cutting off one side of the fruit, leaving the

stem extending from one end of the vessel where it might serve as a handle. Since decorated gourd bowls were used by personages of rank, the common folk presumably contented themselves with similar undecorated vessels. As their artistic appeal would be lost in comparison with their more elaborate counterparts the incentive to preserve them would not be as great and hence they do not appear in collections. Another type of food container is illustrated by the specimen, enclosed in basketry, in the Canterbury Museum [Plate V, D] and by the specimen, slung in flax cordage, in the Bishop Museum [Pate IV, C].

Food containers [Plate XI, A and B] in the Marquesas were apparently usually of the covered variety. They were made of gourds or coconut shells and hung from the beams of the houses.[75] These covered containers were generally known as *hue* but the gourd variety were specifically *hue mao'i* according to Handy while Linton calls them all *hue*. They were suspended in a net of coconut fibre, sometimes ornamented with small carved bone *tiki*. In general for this group, coconuts were preferred and the use of gourds was rather limited. The known type is neckless but it is believed that formerly a necked type was also used.[76] Linton says that all the *hue* examined in the islands were less than a foot in diameter but the size of wooden *hue* covers found in burial places is indicative that considerably larger vessels of this type were used in the past.[77] The wooden tops were always carved to a fixed pattern and were never used as separate containers.[78] A specific use for a gourd container was to place it under a coconut grater to catch the meat as it fell.[79]

The only mention we have for the gourd food containers of Easter Island is that a large kind called *kaha* was used for keeping boiled potatoes, clothing, or soaked mulberry bark.[80] We can assume, however, that as gourds were the only containers on the island they played a prominent part in serving and handling most foods.

Gourd food containers were extensively used in the Society group at Tahiti where Henry says gourds specifically contained sea water with albacore sliced in it and coconut sauce.[81] From the

same author come two interesting allusions to gourd containers in a legend called the Great Mo'o of Fautaua.

"On one of these occasions it happened that as two women approached the shore with their gourds, one of them saw in a cluster of *mo'u* (sword grass) as immense egg, which she took and placed in an open gourd with a stopper, called a *hue fafaru* (gourd for raw fish), and took to her home."[82]

"For each person was set a coconut-shell cup, containing sauce served from bowls of gourd or coconut shell and wooden dishes, containing the steaming meats and various delicacies..."[83]

In the Austral Islands the popular choice between gourds and coconuts as containers is the reverse of that in the Marquesas and the gourds are preferred for their greater capacity.[84] Here the whole gourd is usually used with a large hole cut in the top and provided with a cover. Sometimes, however, the base only of a gourd will be used to form a shallow bowl-like dish or basin. Container gourds are generally provided with a sennit netting and handle for carrying.[85]

9 – Platters

In the Hawaiian Islands flat slices were sometimes cut from the sides of large gourds to make platters.[86] These could be easily made from a broken trunk, drum or any large gourd, and varied widely in length and width. The native name for these platters is *pa-laau* and they were used for meat, fish, or other food.[87] One specimen [Plate XXI, A and B] in the Harvard collection, is twelve and three quarters inches long and six and one half inches wide. It was collected on the Island of Oahu by Alexander Agassiz in 1885.

The only other reference to gourds as platters is by Aitken for the Austral group who was told that gourds were formerly split lengthwise and used as platters although none were seen by him.[88]

10-11 Containers for preserving food

The Maori of New Zealand made the most extensive use of

gourds as containers [Plate VII] for the preservation of food. They also used containers called *patua* made of *totara* bark for the same purpose.[89] For the gourd containers, a large fruit was selected and the stem end cut off to form an opening. A carved wooden mouthpiece named *tuki* was laced to the top, and the gourd was covered with plaited basketry and supported on three legs, the tops of which were ornamented with feathers. Andersen states that four supports were sometimes employed.[90] These elaborate containers, whose native name was *taha huahua* or *ipu*,[91] were used for preserving the flesh of small birds in their own fat. Anderson gives a detailed account of the processes used to preserve the birds flesh.[92] Another type, called *mahanga*, used for potting the *tui* bird was made from a dumbell-shaped gourd. Holes were cut in the sides of each of the two bulbous ends. At feasts the vessel rested on its slender waist in a forked stick which was stuck in the ground.[93]

In the Austral Islands fish is cut into strips, cured with lime juice and put into gourds filled with fermented sauce and is called *miti hue*.[94] As Aitken says that the fish is supposed to be better after a day or two in the sauce, the implication is that these containers were not used for keeping the cured flesh over several months as were those of the Moari, but only for storing or curing for a few days.

12 – 13 Trunks

Two types of trunks were made from gourds by the Hawaiian Islanders. One type [Plate IX, A] was large and light and slung in a net. It was used for traveling, and when not being used for that purpose served as a storage trunk hung up in the house.[95] The other type [Plate IX, D] was a storage trunk for household use only and was covered with a fine basket work making it heavier and more substantial.

The traveling trunks were used in pairs, suspended from the *auamo*, or carrying stick. One contained a supply of food, the other clothing and personal effects of various kinds. Craft gives an excellent illustration of an old Hawaiian carrying two trunk

gourds.[96] Lawrence says these large light gourds were used to store away tapa, feather capes, *olona* nets, and other articles.[97] A tree with branches lopped off sometimes served to hang these gourds which were equipped with nets of *koko*.

A specimen of a traveling trunk [E 5,375] in the Salem collection, acquired in 1859, is made of a large gourd about two feed in diameter. Part of a second gourd forms the cover and the total height of the vessel is two feet. The trunk is slung in a net of twisted coconut fiber cord. Another specimen [Plate IX,A], in the Harvard collection, is unusual because of the container section is ornamented with burnt on decorations. The diameter of this specimen is 17 inches and the total height 20 inches.

Storage trunks covered with fiber work were called *ipu hokeo* and were used for storing clothing. A good example of this type of container [Plate IX, D] is in the Salem collection. The bottom is made of a thick-shelled gourd, 16 inches in diameter. Part of another gourd forms the cover and both sections are covered with very fine basketwork. There are loops attached to the basketwork for attaching the lashing which holds on the cover. The total height of the container is 13 inches.

The only other occurrence of gourd trunks is for Easter Island where they served as containers for storing clothing and were called *kaha*.[99]

14 – 15 Feather and tapa containers

Gourds used only for storing feathers and feather work in the Hawaiian Islands were long and curved.[100] Valued feather capes and leis were kept in them and it has been said they were sometimes so long and curved that they could be hung over a beam or rafter.[101] A cover of a smaller gourd or of coconut shell was made to fit over the mouth. Two specimens [Plate X, A and B] of the type are in the Bishop Museum.

Containers of thicker shelled gourds were used for storing both feather work and prized kapas.[102] A specimen [Plate XI, C] of this type in the Bishop Museum has the cover cut from the same gourd as the container itself in such a manner that two projections

on the cover dovetail into the bowl. The cover was then tied on by two cords passed through two holes drilled on each side. These boxes were used only for household storage rather than for traveling where the thinner walled variety were preferred.

There is a tale in Fornander called the "Story of Lonoikamakahiki" which contains an incident illustrating how kapas were kept in gourd boxes: "...the retainer went to meet Loli and said to him: 'What are you doing, uncovering the calabash of your ward?' Loli replied: 'I am uncovering it for the loin cloth and kapa of the king.'"[103]

Similiar containers were used on Easter Island for storing particularly fine feather work although banana-leaf containers for the same purpose were also known.[104]

16 – 17 Containers for fishing equipment and bait.

Two types [Plate XI, E and F] of gourd containers for fishing equipment and bait used by the Hawaiians are well known and Stokes has this to say about them: *"Ipu le'i, ipu holoholona, pahu aho* and *ipu aho* are among the names used to designate a utensil, consisting of two pieces, for containing fish hooks and lines. There are two general forms of this article: one with the lower and smaller part of wood covered with a larger gourd, and the other of gourd with the lower larger than the upper part. There is some confusion now as to the correct names and uses of the different styles, but the best information seems to be that the former, called *ipu le'i* or *ipu holoholona*, was for the purpose of holding bait in addition to hooks and lines and the latter, *poho aho*, for fishing tools alone. Some *poho aho* were bowl-shaped gourds, covered with half a small gourd or coconut."[105]

The distinction between the two types made by Stokes is good, but apparently the variety called *ipu le'i*, having a wooden bowl with a much larger gourd top does not run true to form. There is evidence that in the smaller examples of this type both the bowl and cover were made of gourds.[106] Also that the cover was not always of oversize dimensions is proved by a specimen [Plate X,D] in the Salem collection [E 14026] recovered by J.S. Em-

erson from the burial cave of Kanupa. The specimen consists of a deep wooden bowl seven and one half inches deep and five and one half inches across its greatest diameter. The cover is made of a piece of tightly fitting gourd with a height of three inches and an overall diameter of five and three-quarters inches. There are three small holes in the cover which Emerson says were for attaching a string to suspend the whole vessel.[107]

Further evidence says that the containers for fishing equipment were usually used only by the well-to-do professional fisherman while the poor man simply tucked his hooks and lines into the knot of his *malo*.[108]

18 – Containers for body paint and dye for tattooing

In Easter Island the yellow or orange dye used as body paint was kept in a gourd called *ki roto ki te ipu*.[109] A gourd was also used for holding the dark pigment used for tattooing.[110]

19 – Gourd for feeding fowl

The only information for this Easter Island vessel is from Thomson who says: "Calabash — called Epu Moa. Known as the fowl gourd, and a superstition ascribes a beneficial influence over the chickens fed and watered from it."[111]

20 – Gourd for burying an egg

This peculiar use is restricted to the bird cult of Easter Island. The natives raced to get the first egg of the season, and the winner or bird-man kept the egg he brought back for the year. "When in the following spring the new bird-man had achieved his egg, he brought it to Orohie and was given the old one, which he buried in a gourd in a cranny of Rano Raraku: sometimes, however, it was thrown into the sea, or kept and buried with its original owner."[112]

21 – Container for offerings

McAllister, in excavating a shrine on Kahoolawe, found, besides other bundle offerings, a gourd containing tapa, fish bones,

a fish jaw, pieces of basalt, and sugar cane.[113] A somewhat analagous use is found in the Marquesas where food offerings to the dead are hung in gourds near the corpses.

22 – Ossuary urn

So far as I know no bones of Hawaiians have ever been found buried in gourd containers. Hawaiian mythology, however, contains so many instances of the bones of individuals being cleaned and kept in gourd urns that the stories must have had some basis in fact [See p. 75].

23 – Spittoons

Hawaiian spittons were commonly carved out of wood but Bishop says "In the early days of the American Mission, the Hawaiians were in the habit of carrying with them to church and other places of public assembly, a bowl or gourd shell to be used as a spittoon."[114] This is the only reference I have seen to a gourd spittoon, although there is no reason why a gourd should not have been so used. Wooden spittoons are, of cource, well known and numbers of specimens of them exist.

24 – Covers

In Hawaii gourd covers were made for both gourd and wooden bowls.[115] Besides covers for food containers gourds were used to cover both types of vessels already described used to contain fish bait and fishing equipment. As has already been mentioned both types of large trunks had gourd covers, some enclosed in basket work. Most of the covers also served as dishes when the containers were uncovered. Fornander in an ambiguous sentence about covers mentions them particularly for gourds containing fish and water.[116]

CHAPTER IV
MUSICAL INSTRUMENTS

From the jungles of Africa to the great plains of North America, gourds have given forth many sounds both as noise makers and musical instruments. Commonest gourd instrument is the rattle, but many notes are produced by elaborate African xylophones, called *marimba*, using gourds as resonators. Another instrument, occurring with many variations in numerous localities of Africa is a stringed bow with a gourd resonator attached. From other regions of the world come the whirring of the bull roarer, the shrill of the whistle, and the haunting cadences of the hula drum. Gourd drums, as well as gourds as resonators for stringed instruments, are also used in India, while tribes in the interior of Brazil made gourds into trumpets. The Chinese attached whistles made of gourds to the tails of pigeons to frighten birds of prey, and they also blew them in ordinary fashion.

In Polynesia seven different kinds of musical instruments appear, made entirely or in part of gourds. It is possible that other types existed in pre-European times but evidence is too slight to warrant any conclusions.

25 – Rattles

It is highly probable that the commonest musical instrument made of a gourd is the rattle. This in Polynesia appears as the Hawaiian instrument which rejoices in the native name of *uliuli* — one native name upon which all the authorities agree [Plate XV]. The rattle was made of either a gourd or a coconut — Roberts says that the specimens she examined were about equally divided between the two.[1] In making the rattle the inside of the gourd was removed through four holes cut in the top, which ultimately served for the attachment of the handle. After the shell was prepared it was loaded with the small hard seeds of the little wild yellow canna (*ali'i poe*), but Bryan gives pebbles as an alternative.[2] According to Roberts: "'Strips of *ie* (*Freycinetia aborea*)

were drawn through the holes at right angles while they were green and pliable, and the ends, gathered together and wound with more *ie* formed the handle."³ In two specimens in Mrs. Bishop's collection the handle is wound and tied with olona cord.⁴ The handle was sometimes left plain and at others decorated with a disc of tapa, skin or cloth fringed with feathers. Emerson thinks that the disc and feathers are modern innovation,⁵ but Roberts points out that Barrot in 1836 said of these instruments "... they waved with violence the feather fans which they held in the left hand, and the base of which, formed of a small calabash filled with shells and struck by the right at regular intervals, performed the office of castanets."⁶ A still better proof is Webber's drawing in the plates of Cook's third voyage which shows a Hawaiian dancer with a *uliuli*, obviously well feathered.⁷

The rattle has been most fully described by Emerson, Roberts, and Bishop.⁸ Three specimens, two elaborately decorated with feathers, are figured in the Bishop Museum Handbook.⁹

The instrument was and still is used in dancing the hula. In fact one hula is named from this rattle, which forms its only accompaniment,¹⁰ the rattle not only being shaken but struck on the palm of the hand, the thigh, and the ground.¹¹ Emerson says that in pre-European days this hula was preceded by sacrificial offerings of *awa* and roast pig in honor of the goddess Laka.¹²

These specimens are usually rubbed down and polished but are not usually decorated. One, however, in Mrs. Bishop's collection is ornamented with burnt-on lines and stars.¹³

26 – Spinning Rattles

An instrument for which it is difficult to find an English word was used in the Hawaiian Islands and was known by the native name *ulili* [Plate XVI, A and B] Emerson does not mention this contrivance at all but says *ulili* is simply another form of the word *uliuli*; an entirely different instrument.¹⁴ This unusual noise-making device or toy has had considerable doubt cast on its antiquity because it was formerly known from only two specimens purchased by J.S. Emerson in Hawaii about 1885,¹⁵ although the

collector refers to the instrument as if it had been known to the natives for a long time.

Evidence in favor of its antiquity is increased by a fragmentary specimen in the Peabody Museum of Salem collected by either the Reverend Asa Thurston or his wife sometime between 1820 and 1868.[16]

The *ulili* consists of three gourds strung on a stick. The two outer were stationary while the middle one was loose. A cord attached to the center of the stick came out through a hole in the side of the center gourd. To facilitate pulling the string and to prevent the end of the string from becoming lost in the gourd, a small stick or piece of sharkskin was attached to the end as a toggle. In operating, the center gourd was held firmly in the left hand and the string, which had been wound up around the stick, pulled quickly with the right hand. If this operation was performed successfully the momentum would cause the string to rewind itself and it could then be pulled again and the performance continued indefinitely.

Roberts says a specimen examined by her consisted of a stick about fifteen inches long and an inch or more in diameter,[17] strung with three gourds, fixed pear-shaped ones with ends pointing out at each end, and a loose, round one in the center.[18] A reproduction made for Mrs. Bishop, now in the Salem Museum, follows this general form except that all three of the gourds are round, and the two end gourds have been loaded with seeds or some other substance to form a rattle. Apparently the Emerson specimens did not have the rattling substance nor has the Salem instrument. The Salem specimen is much smaller than that of Mrs. Bishop or those described by Roberts. The stick is only about a foot in length and a quarter of an inch in diameter. The gourds are pear-shaped but only two survive. One of the end gourds is present, solidly fixed with the small end towards the center. The center gourd, also pear-shaped with small end towards the surviving terminal gourd, is loose. A fragment only of the cord remains. On the end lacking a gourd there is a gourd washer about an inch and a half in diameter.

The approximate date and known collector of the Salem specimen, supported by the Emerson specimens, seems to indicate pretty conclusively that this instrument was part of the pre-European culture in Hawaii. Evidence indicates that the *ulili* may have been confined to the Kona coast of Hawaii. The two Bishop Museum specimens were collected here,[19] and without much question the Salem specimen was acquired in this same general region which was where the Rev. Asa Thurston and his wife lived.

The instrument was unknown elsewhere in Polynesia but gourd tops of a really free spinning variety were used by the Maori of New Zealand (See p.47).

27 – Drums

The type of drum, native to the Hawaiian Islands, called *ipu hula*,[20] and used in the hula dance has been described many times,[21] [Plate XVI, C and D]. It varied from sixteen inches to three feet in height and was made of two gourds cut off at the neck and stuck together, probably with breadfruit gum, in such a manner as to form a common air chamber. Bryan asserts that the two gourds were joined by inserting the neck of one within the other.[22] In specimens available to me I have been unable to find any evidence of this method. The cutting is usually so neatly and accurately done that the two gourds butt without either being really inserted into the other. Roberts states that occasionally the upper and lower gourds were not directly attached but were separated by a collar cut from a third gourd.[23] This method, illustrated by a specimen in the Harvard collection, creates two joints, fitted and stuck with gum, instead of the usual one [Plate XVI, D]. The instrument resulting from the jointing of the two gourds presented somewhat of an hourglass or figure-of-eight profile, although because of variation in the gourds the shapes differed widely. The drum was completed by cutting a hole, three to four inches in diameter in the top of the upper gourd, and two small holes in the lower gourd near the joint for inserting a loop of tapa or cloth to aid in handling the somewhat ungainly affair.

Roberts remarks that a cord or cloth was tied about the stricture to aid in transportation.[24] As she does not mention cloth or tapa being attached through the two small holes in the lower gourd, I assume that she refers to a variation of this device and not to a special attachment used only when transporting the instrument. I have never seen any attachment of this sort in either specimens or photographs.

Two specimens of these drums, both in Salem [E 11,954] are good examples of the common type. Two specimens in Cambridge both show interesting variations. One [Plate XVI, D] has the collar cut from a third gourd inserted between the upper and lower parts. The other [Plate XVI, C] is the only known specimen which is extensively decorated. Nearly the entire surface is covered with pyrogravure designs. This specimen has an unusually long lower gourd, the total height of the instrument being twenty-seven and one half inches and the height of the lower section twenty-one inches. Three specimens in the Bishop Museum have some slight decoration, but nothing approaching the elaborateness of this example.[25] One Salem specimen has a single line, hardly ornamentation, around it just below the juncture of the gourds. This creates something of an illusion as the appearance is not unlike that of the specimen with a collar of a third gourd already mentioned.

The method of playing on the gourd drum is best described by Roberts, although Emerson and Bishop present some minor variations.[26] All agree that the drum was first raised in the air and then dropped on the ground for the first beat. Bishop lets it go at that, while Emerson says the ground was the padded earth-floor of a house and Roberts describes the pad as a cushion or piece of folded cloth in front of which the player sat tailor-fashion. Emerson says nothing further about the actual striking of the instrument except that the style could be changed at the will of the player from light and sentimental to wild and emphatic. The other two authorities both say that it was next lifted in the air and the sides of the lower gourd struck rapidly — Bishop says with the flat of the hand, and Roberts with the flat of three or four fingers.

There was considerable contrast in the sounds made between the dropping on the pad and the slapping. Another method is well described thus: "The second method was to place the ipu on the pad, and to lift it at the first beat to the right on a level with the shoulders, striking it with the hand as it reached the end of the swing. It was then brought down and struck just as it reached the lowest point of the arc immediately above the pad. The third beat occurred when the highest point to the left was reached, and the fourth as it returned to the lowest point of the arc."[27] The pitch of the instrument was low; and the sound, though loud, had no great carrying power. Emerson states that it had a clear bass tone and that a specimen in his collection gave the tone of C in bass.[28]

So far as is known the only other locality to use a gourd drum without a skin top is India which leads one on to interesting but perhaps not too sound speculations.[29]

28 – Sounding chambers

A use for the gourd somewhat analagous to that of the hula drum is found in Easter Island. Two accounts appear which are so much at variance that it seems desirable to quote them both.

According to the earlier account by Routledge: "A more formal ceremony was held in a large house. This had three doors on each side by which the singers entered, who were up to a hundred in number, and ranged themselves in lines within; in one house, of which a diagram was drawn, a deep hole was dug in the middle, at the bottom of which was a gourd covered with a stone to act as a drum. On the top of this a man danced, being hidden out of sight in the hole.[30]

Metraux's more recent account states that: "The percussion plate was made by digging a hole about three feet deep and one to two feet wide. A large gourd, half filled with tapa or grass, was placed in the hole, which was covered with a thin stone slab. A man stepped on the slab, and with his feet beat time for dancers and singers."[31]

"The women squatted on their knees in front of the man who tramped the resonance box dug in the ground."[32]

It is unfortunate that we have no other information about this interesting device. Routledge's account prompts several questions. Certainly no gourd would be strong enough to support a flat stone with a man jumping around on top of it. There must have been some way of supporting that flat stone, and keep the weight off the gourd, although this is not mentioned. Also it is hard to imagine any volume of sound coming from the bottom of a hole deep enough to hide a man, particularly when the sound-producing device is such as above. On the whole, Metraux's account seems the more plausible of the two.

29 – Whistles

The Hawaiians made a whistle called *ipu hokiokio* from a small gourd.[33] These may be the same instruments discussed under the next section on swing tops where it is stated that they were called lover's-whistles and were used to exchange signals at night by lovers who swing them on the end of a cord.[34] Bryan also gives them the name 'love-whistles' but offers the more orthodox explanation of producing sound by blowing through the nose.[35] As the term 'love' or 'lovers-whistles' occurs in other sources with more or less frequency, probably this amatory use has some factual basis. Emerson likens the instrument to the Italian ocarina.[36] Although most of the descriptions in the literature say it was played with the nose, the fact that some writers mention nose or mouth, plus the size of one of the specimens [Plate XVIII, A,] which will be described later, leads me to believe that the whistle probably was blown on occasion with the mouth.

As with other Hawaiian musical instruments, the fullest account of this whistle is by Roberts,[37] who cites evidence that in addition to the usual gourd these instruments were occasionally made of the shell of a nut called *kamani* (*Calophyllum inophyllum*). Roberts says the instrument had two tones about half a step apart and probably it was rather monotonous, although there are indications that it was pleasing to the Hawaiians.[38] The two tones seem reasonable for the instruments having two holes of different sizes or two holes spaced at different distances from the

embouchure; but it would also seem that those instruments having three holes of different sizes, as many of them have, would produce three tones.

Roberts has written so good a summary of the distribution of gourd whistles throughout the world that there is no point in going outside of Polynesia here.[39] However, since her statement that "gourd whistles were supplanted by those of clay, bone or wood in the Americas", Speck has described and figured a mouth blown whistle called a "blow gourd," very similar in appearance to the Hawaiian instrument, used by the Chickahominy and Pamunkey Indians of Virginia.[40]

The sizes of the gourds, or occasionally nuts, used to manufacture the Hawaiian whistles range, in the specimens measured, from one and one sixteenth inches long and one and one eighth inches in diameter to three and one quarter inches long and three inches in diameter.

All of these whistles fall into two types which may be called end blown and side blown. The blow hole of the end blown variety is formed by the simple method of cutting off the small end of the gourd. In the side blown type the blow hole is cut in the side of the gourd about one to two centimeters from the small end. The end blown whistles can be operated easily by either the mouth or the nose but it is almost impossible to blow the side hole type with the nose unless the hole is unusually close to the end. Consequently we apparently have here the answer to the divergent statements of earlier authors regarding the blowing method.

There are usually two or three note-producing holes but the number is not consistent. Two methods of placing the note producing holes are most prevalent. In one arrangement the holes, usually three in number, are placed in a straight line about half way down the gourd [Plate XVIII, D, F, and H]. The second usually involves only two holes, one of which is always placed higher than the other [Plate XVII, XVIII, A and B]. Whistles with holes located in other ways are uncommon but one with only a single note-producing hole [Plate XVII, A] and others [Plate XVII, H] with three holes abnormally placed were found. One

specimen [Plate XVII, C] with two note producing holes had a third bored and then plugged and a fourth hole started and never finished. The proximity of the hole that was plugged to one of the present holes may possibly indicate that this was one of the original note-producing holes but proved to be in the wrong position to give the proper pitch.

Two specimens [Plate XVIII, F and H] have a hole very close to the embouchure. I believe the purpose of this may have been for fastening to the end of a cord for swinging around the head (See section on swing tops).

All the specimens examined are old with the possible exception of two in the Salem Peabody's collection which deserve special comment. These two whistles were originally in the collection of J. S. Emerson but where he obtained them is not known,[41] so there is the possibility they may have been reproductions made for him by some native. They do not show signs of use as do the others; and further doubt is cast upon them by the fact that the note-producing holes are burned through, whereas in the known old specimens the holes are apparently either cut or drilled. Although these facts tend to cast some doubt upon the two specimens, so little is really known about these whistles that the chance they may be genuine variations of the commoner type must be considered.

The unusual use of a gourd whistle as a ball in a cup and ball game is illustrated by Edge-Partington and reproduced by Andersen and Best.[42] This is described and discussed under the section on cup and ball games in the next chapter (p.51).

The only other islands of Polynesia to which these whistles have been attributed are, so far as I know, Tahiti and New Zealand.

The only evidence for Tahiti rests on two whistles in the British Museum, one made of a gourd and one of a nut, figured by Edge-Partington as belonging to this group.[43] Andersen reproduces Edge-Partington's drawings and — I believe correctly — attributes both specimens to Hawaii.[44] As this is the only reference to the instrument in Tahiti which I have been able to

find and as Edge-Partington's localities are many times incorrect, it seems reasonable to assume that the gourd whistle was never used in Tahiti, at least in historic times.

The evidence for the gourd whistle in New Zealand seems a little better than for the Society group. In New Zealand there seems to be some confusion between a gourd whistle and a gourd trumpet. To refer to the insignificant sounding little whistle as a "Calabash trumpet"[45] is, to my mind, nonsense. Here, however, we are concerned only with the whistle; the trumpet will be discussed in a separate section. A good deal of the evidence for the existence of this instrument in New Zealand is based on the specimen in the British Museum figured by Edge-Partington and redrawn by Anderson.[46] This same specimen is also referred to by Best and Hamiliton and constitutes the tangible evidence regularly trotted out to clinch the argument for the existence of such an instrument in New Zealand.[47] Now if one will but look at the sketch of a gourd oil vessel figured by Edge-Partington on the same page with the whistle it will be readily noted that the ornamentation is typically Maori. The ornamentation on the whistle, on the other hand, is not only unlike any Maori decoration but on the contrary appears rather characteristically Hawaiian. The arrangement of the holes, too, is typical of the Hawaiian instrument. Its only pecularity is the same as that in the Hawaiian whistle used in a cup and ball game (see p.51). Here again how this could be blown with two holes very close together I cannot conceive unless one was always stopped. Consequently I regard this specimen as one of the Hawaiian "swing-tops."

The elimination of the British Museum specimen does not, however, dispose of the gourd whistle in New Zealand. Hamilton, Best and Andersen all refer to Moser's account of a gourd "in the side of which were punctured two or three holes" and from which the natives "succeed in some way peculiar to themselves in extracting a most horrid noise." Moser further says the instrument's name was *rehu*. Hamilton thought the instrument was localized to the natives of the Taranaki coast and Treager supports this conclusion.[49] Anderson cites Baucke as mentioning a

gourd instrument called a *nguru* and says that "instead of being blown, was softly crooned into, very mournful, but not unpleasant if a woman's voice crooned in perfect time.[50] Andersen also cites evidence from a Mr. G. Graham who gave the name *nguru* to a "gourd trumpet".[51]

Best, speaking of what he erroneously calls "nose" flutes (*nguru*), says he was told that small gourds were occasionally converted into "nose" flutes which were called *koauau pongaihu*,[52] but that it required good lungs to produce a sound from such an instrument.[53] He figures the familiar British Museum specimen and notes that the small hole near the end of the gourd is similar to the hole arrangement in the *nguru* and is a New Zealand trick.[54] The *nguru* is a mouth flute and the hole arrangement is not a "trick", which combined with the almost certain Hawaiian origin of the gourd in question disposes of his theory.[54A]

It is interesting to note that *nguru* is the accepted name of the wood, stone, or ivory flutes with a curved end, the instrument being somewhat gourd-like in shape. It is far too much to assert but is is tempting to speculate on the possibility of the gourd whistle being formerly used in New Zealand but surviving into historical times only in one or two small localities. As gourds did not grow throughout the islands, substitutes in a gourd-like form may have been made which eventually, aided by ecological conditions, may have supplanted the original gourd instrument; the name *nguru* carrying over to the wood, stone, or bone forms and remembered in a rather confused way as having been applied to a gourd instrument. In these circumstances the name may have been applied to a trumpet made of a gourd.

Summing up, the gourd whistle, blown with either the nose or mouth, is definitely present in Hawaii and is lacking in the Society Islands. For New Zealand one can only say that the evidence is most unsatisfactory but is such that one must admit the probability of its localized existence and the possibility that it preceded the common type flute (*nguru*) in parts of the country.

30 – Trumpets

While no specimens have survived there is fair evidence of a gourd trumpet having been used by some of the Maori tribes of New Zealand. Hamilton used the term "calabash trumpet" but described only the small whistles.[55] Anderson does much the same thing, but then quotes Mr. G. Graham who describes what is apparently a real trumpet made from a large curved gourd.[56] He mentions it having "a hole bored in the neck to vary the sound" in addition to the hole in the end used as a mouthpiece. This is similar to the placing of holes in the flutes. Best quotes an east coast native informant as saying that his people made horns from elongated gourds having a curved shank.[57] Both ends were cut off and a wooden mouthpiece fitted to the smaller end. The same author really distinguishes for the first time two distinct instruments.[58] Here he describes the horn or trumpet as above and quotes his informant, Nihoniho, as saying it was formerly used in the Waiapu district and was blown like the familiar Triton shell trumpet. Here also he mentions the gourd trumpets as being an elongated form quite different from the whistles.

So far as is known the gourd as a trumpet occurred nowhere else in Polynesia.

31 – Swing tops

I have coined the term "swing top" for the instrument about to be described, rather than use the name "bullroarer" which has been applied to it in the past. The ordinary type of bullroarer, made of a flat piece of wood and attached to a cord, is of wide distribution throughout the world and is known in several localities in Polynesia. The instrument is whirled around the head and makes considerable noise. Instruments made of gourds or nuts work on a different acoustic principle. They are essentially humming tops swung on a string instead of being revolved on their own axis.

The evidence of gourds used as swing tops in Polynesia rests entirely upon literary sources; since no actual specimens are known. Roberts came across a Hawaiian child's toy,[59] which she

figures was made of a coconut. She was unable to find any native name, but describes it as having an orifice about an inch in diameter at the top with a tiny hole on either side of it for the attachment of a cord. Presumably a gourd specimen would have this same hole arrangement. Edge-Partington figures a somewhat similar instrument made of a *kamani* nut and having four small holes in the top through which a cord is attached.[60]

The Bishop Museum Handbook refers to "small gourds with from two, three to five holes, called *ipu hokiokio* or lover's whistles, used for nocturnal amorous signals by swinging attached to a cord as a bullroarer."[61] These are obviously the well-known gourd blow whistles and whether they were ever attached to cords and used as "bullroarers" I believe is questionable. I think it more probable that there were two distinct instruments, the whistle and the swing top; the swing top made either of gourd or coconut and having a hole arrangement as described above. Later natives describing this instrument as a small gourd with holes in it, the assumption was made that the instrument was the more familiar whistle. Of course there is the possibility that the whistle really did serve the dual purposes attributed to it.

The curious specimen [Plate XVII, G and H] figured by Edge-Partington, Andersen and Best, and described in the section under whistles,[62] although apparently a cup and ball game, could probably be swung around the head. The hole near the embouchure would serve admirably for the attachment of a cord. The similar specimen in the British Museum (see p.51) with a hole similarly placed would also serve this purpose. Possibly both of these specimens are old examples of swing tops.

Roberts gives Best as referring to similar instruments in New Zealand but I can find no account of a gourd used for this purpose in New Zealand on that or any other page of the work referred to.[63]

Apparently this somewhat questionable instrument from Hawaii is the only record of a gourd swing top for all of Polynesia.

CHAPTER V
OTHER USES OF GOURDS

Primitive man after the obvious containers and rattles were made did not stop inventing uses for gourds. Many and ingenious were the purposes to which the fruit of this useful plant was put. Tops, floats, funnels, lures, reels, and many other things were made from the easily prepared and worked rind of *Lagenaria*.

While an impressive list of use classifications has been prepared and many obscure appliances have been brought to light for Polynesia, no doubt nearly as many more utilizations employed in the past, in the same region, have been lost forever.

There is, for instance, one purpose attributed to the gourd which, over the years, has generated considerable controversy. As an instrument of navigation the gourd has been written about many times — particularly by journalists.[1] There is no need to repeat all the detailed pros and cons here, but, in summary, it all began with an article by Admiral Hugh Rodman in the *United States Naval Institute Proceedings* in 1927 entitled "The Sacred Calabash", and reprinted in *"The Journal of the Polynesian Society"* the following year. Rodman maintained that he had found evidence, including a specimen in the Bishop Museum, that a navigating instrument made of a gourd was used as a crude sextant on long Polynesian voyages. In 1928 John F. G. Stokes refuted Admiral Rodman's theory in a note in the same two periodicals saying that the Bishop Museum specimen was not a navigating instrument but a container for carrying clothing. Te Rangi Hiroa, in an article published previously in 1926 also indicated his suspicions of such an instrument. In his *Arts and Crafts of Hawaii* (1957) he went into the subject in more detail and concurred with Strokes.[2] Lewis (1952, p.238n.) agrees with Stokes and Te Rangi Hiroa.

However, the subject is far from laid to rest. Rubellite Kawena Johnson and John Kaipo Mahelona, in their book *Na Inoa Hoku* (1975, pp. 70-75) have quoted an article by Samuel Kamakau

which appeared in the July, 1865, issue of *Ka Nupepa Ku'oko'a*, translated by the historian W.D. Alexander, giving a complete description of how to construct a gourd navigating instrument and directions for its use. They concede that while such an instrument has been given little credence in the past that references to the gourd "compass" occur elsewhere in Polynesian traditions and cite the chant collected by Frank Stimson in the Tuamotos and published in his *Songs and Tales of the Sea Kings*. (Salem, 1957). It deserves requoting.

Oh my calabash!
Blown toward me by the wind,
My calabash rolls over and over
 on the toppling waves.

It is my diviner,
 giver of the wisdom of the stars.

Oh my calabash!
Old memories of my beloved homeland
 crowd into my heart.

Oh my calabash!
Bringing me a brother's life-saving love
My calabash turns over and over
 on the crested waves.

It is the first of my possessions
 to be borne hither to my side,
Drifting into my welcoming hands.

Oh, my sacred calabash —
Revealing the sacred wisdom of the stars

 While no actual instrument appears to have survived, in the light of these most recent writings, it would seem therefore that

the subject deserves a new objective study by a person well versed in both Polynesian navigation and tradition and with some knowledge of early European navigation before a final firm opinion can be given on the subject.

32 – Tops

Humming tops called *potaka hue* were made of gourds by the Maori of New Zealand, although their commoner variety was made of wood. According to Best "The *potaka hue* or gourd humming tops were made of small sized gourds as a rule, occasionally a medium sized one was employed for this purpose. In order to form a spinning point a stick was thrust right through the middle of the gourd so that its ends projected, that at the bottom as a spinning point, and that at the top as a shaft or spindle on which to wind the cord. One or two holes were made in the sides of the gourd in order to cause it to hum well when spun. It was through the holes made for these purposes that the dried up *pukahu* or inside matter of the gourd was abstracted. It took two persons to set spinning one of the larger gourd humming tops, one to hold the *papa takiri* or spinning stick, and another to pull the cord."[3]

The technique of spinning all Maori humming tops has been described by Best: "The cord was wound from the top of the shaft downwards to its base. Then a small stick, like a diminutive shepherd's crook, was hooked by the left hand over the cord held in the right hand, and slid along the cord until it rested sideways against the base of the shaft. Then, with a finger curled round the shaft to keep it in position, the operator pulled the cord vigorously with his right hand, thus causing the top to revolve and the cord to unwind."[4]

The spinning of tops was an adult amusement. When contests were held the top which spun the longest won, but the tops which made the loudest noise seem to have been most highly prized. During top contests the spinners composed and chanted couplets or other ditties and at a signal word they all started spinning their tops.

Best tell us that "When a certain meeting was held in the Wai-kato district prior to the war, for the purpose of discussing the matter of electing a Maori 'King', a curious trial of humming tops was made, of which the following singular story is told, a story for the truth of which I decline to vouch . . . The Wai-kato folk proposed that the representatives of each tribe should make a humming top, and that the tribe whose top hummed the loudest in a competition should have the privilege of electing one of its members as Maori 'King'. The proposal was agreed to, and each of the visiting tribes made a humming top of *matai* wood, the favoured material, and assembled for the contest. But the local folk of Wai-kato made a large *potaka hue*, or gourd top, which they named Te Ketirera, and which hummed so loudly that its owners easily won the contest, and thus elected Po-tatau as 'King'. On such small issues does the fate of a king sometimes depend!"

Following is a translation of one of the stanzas of the song chanted when Te Ketirera was spun:

> "Sound on, O Te Ketirera!
> Let your sound be low
> Lest you be heard afar.
> Hei! Let go."

Similar instruments to those of the Maori have been described from northern Queensland in Australia.

Best adds that "The toy is made of a small gourd about three inches in diameter, besides the holes for the axial stick the gourd is pierced by four holes".[6] It is also stated that the "Queensland gourd top was spun 'by twirling with the flats of the open hands,' no string being used, while the pierced holes to make it hum have only been introduced of late years."[7]

33 – *Toy spinning disc*

A Hawaiian specimen [Plate XXII, D] of this toy in the Harvard collection consists of a flat gourd disc perforated with two holes through each of which runs a cord of olona.[8] The ends of

the string were looped over the thumbs or a finger of each hand with the disc in the middle. The disc was swung with a circular motion so as to twist the cords. By pulling the hands apart, the cords unwound and spun the disc. As the cords overwound, the hands came inwards and the out and in motion kept the disc spinning continuously. The principle was similar to that used in the pump drill.[9] Similar instruments made of wood were used in New Zealand,[10] and the toy was probably known elsewhere in Polynesia.

34 – Toy water bottle

A toy [Plate XXII, B] in the Salem collection is an imitation of a Hawaiian water bottle. The pulp has not been removed although in exterior form the resemblance to the full-sized water bottle is exact. It is slung in a net of olona cord.[11]

35 – Game

A toss game called *kilu*, played by the Hawaiians, had as its principal accessory the top portion of a gourd.[12] An account of the game given by Malo, with supplementary notes by W. D. Alexander, contains one version of the formalities.[13] According to this, *kilu* was played exclusively by the *alii* or upper classes, on alternate nights with another, and somewhat similar game called *ume*, which was indulged in by the common folk. Another paragraph, however, says that the playing of *kilu* continued all one night and was resumed the next. As far as is known no gourd implement was used in the game called *ume*.

The *kilu* game was played indoors. The teams were divided according to sex, five or more to a side, and the men and women sat at opposite ends of the house. The area between the two teams was covered with matting and a broad-based, pointed wooden cylinder was placed in front of each player. Each group had a talley-keeper and a third person presided over the whole proceedings. The presiding officer started the game by standing up and calling "Puheoheoheo" and the people responded with the same remark. If anyone disturbed the silence that was supposed

to prevail during the course of the game his clothing was set on fire.

Malo says that the *kilu* was made of either a gourd or a coconut "cut obliquely from one end to the other." This description of cutting does not conform with the known specimens which are cut square across just below the stem.

A *kilu* was placed in front of each player and a talley-keeper held up the *kilu* to be thrown, announced the name of the player, and stated the forfeit demanded if the *kilu* hit the mark. The talley-keeper of the opposing team then responded with the name of the opponent. Thereupon the player spun his *kilu* towards the cylinder of his opponent and if he hit the mark, his talley-keeper announced it. A forfeit was paid upon the scoring of each point and when ten points were accumulated a player became a winner and another forfeit was paid him.

A somewhat different version of the game is that of Fornander who says a special building was constructed, six yards wide and forty yards long.[14] Two poles, with tops decorated with chicken feathers, were set up at each side of the house with a vacant space between them. One side scored over their opponents when the *kilu* struck the pole. Each strike counted five and the side scoring forty first won. People beaten had to dance as a forfeit. If the player threw the *kilu* and missed the pole he chanted.

> "Missed, missed by a wide margin;
> Kapakapaka, that is not the pole."
> (careless or blundering?)

If, however, the scorer struck the pole, he recited

> "Hene uha (The thighs rejoice)
> The edge remains,
> The edge remains;
> The day is tumultuous,
> The day closes sadly
> We have five down through."

A good deal of repartee and boasting went on between the players during the game.

There are also accounts of this game by Emory and Bishop but these are substantially like that of Malo.[15] None of these are any too clear about what went on, and the contradictory elements in them add to the confusion.

Fornander remarks that the gourds used were well finished and "spotted on the outside like a Niihau calabash."[16] A specimen [Plate XXII, C] in Salem collected by the Thurstons, is decorated by pyrogravure with two rows of dots arranged in triangles.[17] It is made from the top part of a gourd and is six and one half inches in diameter. Edge-Partington figures a decorated specimen [Plate XXI,C] of a *kilu* in the British Museum having a diameter of only three and one half inches, [18] while a specimen [Plate XXIII, B] in the Bishop Museum is more conical.

36 – *Cup and ball game*

The only evidence of a cup and ball game involving a gourd is the specimen [Plate XVIII], no doubt Hawaiian, illustrated by Edge-Partington. It consists of a gourd whistle attached by a string ornamented with feathers to a "light wand of twisted leaf ribs with a loop at (the) end."[19] Feathers are attached to the bottom of the gourd so that it will turn over in the air and can be caught in the loop.

37 – *Mock spearheads*

In most of Polynesia, spears are of one solid piece of wood without separate heads. One of the exceptions is Easter Island where the spears were tipped with obsidian. There is a good amount of evidence that young men tipped their spears with pieces of gourd shell to carry on their practice fights.[20] Métraux, the most recent investigator of the Easter Islanders, says "The sham battle was one of the favorite entertainments of children. Divided into two sides, they threw at each other spears tipped by pieces of gourd shell in the shape of obsidian points (*taua pahera*). Legend states that children frequently discovered and substituted obsidian points for their harmless spear points."[21]

38 – Floats

Gourds were used by some of the Southeastern American Indians[22] as floats both for net lines and for swimming. One might then suspect a similiar use among people more intimately concerned with the ocean. The only evidence, however, is of a sport of the Hawaiians called *kaupau* which consisted of swimming or diving for a small, half-ripe gourd that would barely float,[23] and an unelaborated statement by Best that gourds were used occasionally as floats by the Maori.[24]

39 – Decoys

A unique method for escaping the tiger shark, employed by Hawaiian fishermen, is cited by Handy. Several large bottle gourds were carried in the fishermen's canoe for the specific purpose of throwing overboard when a tiger shark was sighted. The gourd was thrown high in the air to one side of the shark and hit the water with a sharp splash. Whereupon the shark would turn from the canoe and head for the new attraction. As the shark attacked the decoy, it would bob away each time the fish's nose hit it. While the infuriated animal tried to bite the gourd the fishermen hurried ashore.[25]

40 – Lure

The use by the Hawaiian Islanders of a piece of gourd called *pohue* as lure for catching a kind of fish call *maomao* is recorded by Fornander: "The *pohue* bait is a piece of bitter calabash, made in a circular shape and blackened in the fire, and tied to the opening of the net, thus: there are four sticks encircling the mouth (of the net), and on this mouth the pieces of *pohu* are placed, floating on the sea. The *maomao* on seeing the *pohue* floating takes it for bait and is thus ensnared."[26] Although there are no other records of this lure so detailed an account by Fornander seems to authenticate the report.

41 – Fish line reels

Bits of gourds served as convenient objects upon which fish

lines could be wound [Plate XXIII, A and C]. One Hawaiian specimen in the Bishop Museum is made from the broken neck of a gourd bottle and could be handled easily, as by holding with two fingers the delivery of the lines could be readily controlled. A simpler reel, from the same group, is an ordinary fragment of gourd.[27]

42 – Bailers

There is one indication that gourds may have been used as canoe bailers in the Hawaiian Islands. On Kahoolawe there was found a gourd "made into a small scoop-like vessel, with two holes near the rim. It may have functioned as a canoe bailer."[28]

There is somewhat better evidence that gourd bailers, called *tata*, were quite extensively used on Easter Island.[29]

43 – Syringes

The medical practices of the Hawaiians included an enema to empty the lower bowel. The syringe used for this purpose was commonly made of the upper end of a gourd and was called *hahano ipu*, although specimens made of bamboo and even a cow's horn are known.[30] The gourd specimens were funnel-shaped, with a hole at the small end where the stem joined the gourd and a large opening at the opposite end.

In administering the enema the patient knelt on the ground with his head down. The small end of the syringe was inserted in the anus and the kahuna forced the liquid into the bowel by blowing into the open end of the gourd. The enema usually consisted of an infusion of *hau* bark in warm water.[31]

44 – Funnels

The Hawaiians used gourd funnels to fill their small-necked gourd water bottles.[32] Several specimens have been preserved in the Bishop Museum and two of these,[33] of entirely different types, are figured by Brigham. One type [Plate XX, A] is a true funnel made of an hourglass-shaped gourd. The stem end is cut off to form the aperture and the base of the gourd is cut off to form a

large opening into which the water can be easily poured. I assume that the upper ends of gourds of other shapes, perhaps like the syringes, were also probably used as funnels. The other type [Plate XX, B] is not, strictly speaking, a true funnel. It is made of a round gourd with a long thin neck. The gourd is cut in half to make a round dish with a long spout out of which water could be poured in a thin stream. Opposite the spout a section of the rim juts up forming a lug with a hole and a cord for hanging the utensil up. Brigham tells of an interesting incident he observed that involved filling a bottle without a funnel. "All along the coast of Oahu, east of Diamond Head, springs of fresh water are found below the sea level, and near Leahi one of considerable size and force of current exists. My native diver placed his thumb over the neck of his empty *huewai*, plunged into the sea and soon emerged with a bottle full of sweet water."[34]

45 – Strainers

In the manufacture of the drink known as *kava* (Hawaiian *awa*) a strainer was required to separate the woody fibre of the root from the liquor. The Hawaiians sometimes made strainers by partly filling a gourd funnel with vegetable fibre and pouring the liquor through it. Speck noted the same double use for the funnel among the Southeastern Indians, but the method employed was stretching a piece of cotton cloth across the mouth of the funnel instead of filling it with vegetable fibre.[35] In addition to the converted funnel a special gourd strainer was also occasionally made and a third form was constructed from half a coconut.[36] The specially made gourd strainer somewhat resembled the funnel made of half a gourd [Plate XXIII, D]. It differed by using more than half the gourd, with the result that the spout was closed and not open along the top. This neck was then loosely filled with fibre and the liquid strained through it. Lawrence remarks that occasionally the neck of the bottle was loosely filled with fibre and served as a strainer. Presumably she is referring to the use of funnels as strainers.[37]

46 – Lamps

That gourds can be used as lamps is proved by Speck's discovery among the Rappahannock Indians of Virginia.[38] The only evidence of a similar use by Polynesians is another of Best's brief statements that the Maori "uses it (the gourd) as a dish, and even as a lamp."[39] The fact that the Hawaiian name for their lamps, which were always of stone, was *ipu kukui* may also indicate that gourds were formerly used.

47 – Masks

Gourd masks probably existed in both the Hawaiian Islands and New Zealand, but in both cases are only scantily documented since no specimens of these fragile and perhaps rare articles survive. For Hawaii the classic citations are two plates in the album to Cook's third voyage,[40] engraved from the drawings of J. Webber, Cook's artist on the expedition.

The original oil painting reproduced in the frontispiece is owned by Mr. and Mrs. John Dominis Holt (and engraved as Cook's Plate 65)

The frontispiece (Cook Plate 65) shows a double canoe with seven paddlers and three passengers all wearing gourds over their heads. Each gourd is decorated with a crest of what is probably feathers but may be foliage, while a row of strips of what appears to be tapa cloth along the chin line gives the appearance of a beard. This type of headgear looks more like a helmet than a mask, although a gourd would be of little defensive use. Actually it was apparently a ceremonial helmet worn only by kahunas. The headgear of five of the nine men have open faces, three are barred, and two appear to be entirely covered with a piece of gourd in which a number of small holes have been cut. The men in this group appear to be on some kind of a special mission as one is holding a feather god and two others hold unidentifiable objects. This might lend a little weight to the ceremonial use of the mask. A black pig is on the platform between the canoes, partly hidden by one of the paddlers.

Plate XXIV (Cook Plate 66) is the portrait of a Kahuna wearing a gourd mask. Here the face, though open, is more enclosed than the open face form shown among the canoe paddlers. This mask is reproduced by Edge-Partington from Webber's original drawing in the British Museum.[41] Whether this type of head-gear covering was part of the paraphernalia used on a particular occasion or not we do not know.

Later references depend mostly on these illustrations. Bishop's statement that "Gourd masks were worn by paddlers in canoes" is based only on Cook's plate, where there are obviously three individuals, not paddlers, also wearing masks.[42] Bryan in a similar brief statement adds that gourd headcoverings "are thought to have been masks rather than helmets for protection."[43] Jarvis merely lists masks among the articles made from gourds and figures a poor redrawing of Cook's plate 65.[44]

For New Zealand there are a few literary references but no illustrations that I know of. One passage figuring a gourd mask is found in James Cowan's descriptive text on the Partridge Collection of Lindauer's paintings of celebrated Maori chiefs (Pictures of Old New Zealand).[45] Cowan is here telling the story of Topeora, a high born woman of the Ngati-Toa tribe living at Kawhia on the west coast of the North Island. The entire extract reads:

"One of Topeora's love-waiatas embalms a memory of her girl-days in the north. There was a chief of the Ngati-Awa tribe, of Taranki, named Rawiri Te Motutere. With him Topeora fell in love, long before she had seen him, simply because of his reputation as a very handsome man and warrior. Te Motutere was a tall active man, straight as a spear; he was an urukehu, that is, he had an unusually fair complexion, almost as fair as a European. His face was beautifully tattooed and on his fair skin the lines of the moko were quite blue. His features were regular and well-formed; physically he was an example of the Maori aristocracy at its best. And he was very proud, not to say vain, of his handsome face. When traveling or in other ways exposed to the sun, he wore a mask, called by the Maori's a matahuna, or "face-hider", in order to protect his complexion. This mask

consisted of the rind of the hue, the vegetable gourd of which the Maoris used to make their taha (calabashes). The hue was cut in two longitudinally and one half fitted over the face, after having been suitably prepared. It was tattooed on the convex side in careful imitation of Te Motutere's moko, and was ornamented at the sides with tufts of feathers (raukura). This curious mask covered the face completely from hair to chin, and was fastened round the neck and head with cords. Holes were cut for the eyes and mouth, and so there stood Te Motutere with his mask ready for the trail or the war-dance. Te Motutere, as his grand-daughter Mere Ngamai told the writer, had another reason besides that of protecting his treasured complexion for wearing his mata-huna. This was to prevent the women of the various tribes he met from falling in love with him because of his beauty."

In regard to tattooing on a gourd Tregear says "That if children in sport tattooed a gourd (calabash) with face-tattooing the gourd was *tapu*, because it had become (metaphorically) a human head."[46] This same evidence is also noted by Robley,[47] who also figures a gourd featuring a tattoo pattern, probably from the right cheek.[48]

Another account of a gourd mask is contributed by Andersen, who has two women talking about proposals for marriage. One tells of going to some sort of meeting where apparently the young men propose to the girls in the presence of elderly people and others. She says "With the others, we entered the *whare-matoro*. There sat the elderly *wahine* with their headdresses of half calabashes hung with hair of *kuri*."[49] This statement is not amplified and I have found no other references to such a use.

48 – Toilet spatula

This use is referred to by Brigham and requires no amplification.[50]

49 – Rat Guards

In the Marquesas Islands bundles were hung from the rafters

by cords which passed through inverted gourd shells as a protection against rats.[51]

50 – Disc Washers

These are simply small, round, flat pieces of gourd with a hole in the center. One can be found on the specimen of the *ulili* from Hawaii described on page 36. No doubt this was an easy thing to make and could be used whenever required. There is no reason to suppose that similar devices might not have been used elsewhere in Polynesia or wherever gourds are grown.

51 – Fire making

The only record I have seen of a piece of gourd ever having been used to produce fire is in Fornander who, writing of the Hawaiian Islands, says: "All calabashes which have a thick shell, fire may be produced thereon by rubbing with wood."[52] Whether this was a possibility indulged in only if required or whether it was an accepted practice it is hard to say. The Hawaiians, in common with other Polynesians, used the plow method of making fire. This necessitated a piece of soft dry wood to be placed on the ground and a hard wood stick for rubbing it. It almost seems that a piece of gourd would be too brittle to withstand the pressure applied, but if it were of sufficient thickness, perhaps not.

52 – Medium for writing or characters

Thomson lists one of the specimens which he brought back from Easter Island as follows:

"Calabash — Very old specimen obtained from an ancient tomb, covered with hieroglyphics similar to those found on the incised tablets. These calabashes grow in profusion on the island, but are worthy of note on account of the prominent place they occupy in the traditions, and because the seed was introduced by the original settlers."[53]

Unfortunately Metraux says this specimen has now dis-

appeared from the Easter Island collection in the National Museum at the Smithsonian Institution.[54]

The only other comparable use is for New Zealand where another Thomson writes:

"During the early intercourse of the settlers with the New Zealanders, pictures of tattooed faces were sometimes marked on land-purchasing deeds in place of signatures, and the ethnologists have pointed them out as a form of hieroglyphic writing; but the idea entirely originated with the settlers, although the natives occasionally conveyed information to distant tribes during war by marks on gourds.[55]

CHAPTER VI
DECORATION AND BASKETRY

Generally speaking, Polynesian art is at its best in wood carving. Almost always the designs on tapa, basketry, mats, or other materials fail to equal the preciseness of technique and careful workmanship shown in the carving of clubs, human figures, canoe ornaments, and other wooden objects.

So far as can be determined gourd objects were decorated only in the Hawaiian Islands and New Zealand, at the extreme north and south of Polynesia. Gourds ceased to be used in most of the groups at such an early date that no evidence remains concerning their use as an artistic medium.

Two types of decoration, except for molding, requiring at least two distinct methods of application, appear in the Hawaiian group.[1] One type is obviously produced by some sort of staining process. The gourds thus decorated have a smooth, sometimes shiny, surface; the patterns are fine and usually light on a dark background, but this is occasionally reversed. Water bottles and bowls are the objects commonly decorated by this method [Plates I, II, XII]. It is well established that this decorating was done almost, if not entirely, on the Islands of Niihau and Kauai, probably as a local deviation from the dominant Hawaiian culture. This type of decoration will therefore be referred to as the "Niihau method". The water bottles in particular were prized in other parts of the islands, where they were known in early European times as "Niihau calabashes". Judging by the number of these beautiful but fragile containers which have survived in collections, the natives of Niihau must have carried on with the other islanders a considerable export trade in their specialties.

The other type of decoration is by no means as frequently seen in collections, except on the gourd whistles where it is the only type employed [Plates XVII-XIX]. It has the appearance of being a burning process or pyrography, although there is some doubt about this and it may turn out to be another form of staining. For

the time being. however, this type will be referred to as the "pyrography method". Gourds so ornamented are never smooth on the surface, but the light areas, which always constitute the background, are slightly elevated above the dark decoration. Aside from the whistles and an occasional specimen such as the rattle [Plate XV, B] and the two *kilu* [Plate XXI, C: XXII, C] the only gourds known that are thus decorated are in the collection given to the Peabody Museum at Harvard University by the Massachusetts Historical Society in 1867. The decorated specimens include a water bottle [Plate II, C and D], a hula drum [Plate XVI, C], a trunk [Plate IX, A and B], and a container of unkown use [Plate XIII, A and B]. The drum is probably the only one in existence decorated to any extent.

Unfortunately, no method survived the impact of European culture long enough to be observed accurately. There are, however, several accounts of the methods and these will be recapitulated and discussed.

The Reverend William Ellis thus described a method observed by him in the Kohala district of the Island of Hawaii:

"In order to stain it [the gourd], they mix several bruised herbs, principally the stalks and leaves of the arum, and a quantity of dark ferruginous earth, with water, and fill the vessel with it. They then draw with a piece of hard wood or stone on the outside of the calabash, whatever figures they wish to ornament with. These are various, being either rhomboids, stars, circles, or wave and straight lines, in separate sections, or crossing each other at right angles, generally marked with a great degree of accuracy and taste, After the colouring matter has remained three or four days in the calabashes, they are put into a native oven and baked. When they are taken out, all the parts previously marked appear beautifully brown or black, while those places, where the outer skin had not been broken retain their natural bright yellow colour. The dye is now emptied out, and the calabash dried in the sun; the whole of the outside appears perfectly smooth and shining, while the colours imparted by the above process remain indelible."[2]

Brigham says: "My notes from the makers of *huewai pawehe* of half a century ago give it as follows: The portion to be left of the natural color of the gourd was covered with a varnish or glaze impervious to water, and the parts to be colored black were then scraped bare and the vessel immersed for a season in the mud of a kalo pond: a sort of etching process. I confess on examining some of the fine specimens in this Museum I do not see how this proceeding could produce such results..."[3]

In regard to Brigham's statement, Bennett says: "It is difficult to understand how such a crude method could produce some of the delicate designs. Another method which Mr. Alexander McBryde used in making decorated calabashes seems much more suitable. A light-brown dye is made by boiling down the *palaa* fern (*Microlepia tenuifolia*) and a dark brown dye from the *alahee* leaves (*Plectronia odorata*) the same shrub from which the *oo* (a pointed tool used in cultivating) was made. Sometimes the tops of sweet potatoes were used as dye. The top of the gourd was cut off with an adz or knife and the insides removed, except for a layer about one inch thick. The design was then scratched on the outside with a tooth, or other sharp instrument, the cut being just deep enough to go through the outer skin of the gourd. The dye was then poured into the gourd and left to stand for days in the sun. Mr. McBryde says the odor resulting from the rotting plants 'injured the comfort of my happy home'. During this time the skin of the gourd must not be touched as it is very tender. The dye is replenished from time to time as evaporation depletes it. When this process is complete the remaining dye is poured out and the gourd is dried. The rest of the pulp is then removed and the inside scraped and polished. The outer skin is then peeled off and the design is left in light color on the dark background wherever the first cuts had been made. The air or the sun, or both, prevent the dye from taking effect on the parts exposed by cutting the skin in making the design."[4]

A somewhat more specific account is given by Bryan: "The gourd to be ornamented was first cleared of the seeds and pulp and then coated on the outside with a thin layer of breadfruit gum,

which made it impervious to water. With a sharp instrument, usually the thumb nail, the gum was carefully removed from the part where the pattern, which varied greatly in design, was to show. This done the *ipu* was buried in taro patch mud for a considerable period. when the color of the soil had become thoroughly set in the shell of the gourd, it was taken from the water and the remaining gum removed, leaving the desired design in two shades of rich brown indelibly dyed in the shell."[5]

Emory, experimenting with old gourds, says: "Regarding my experiments with staining gourds, I found that by inserting a cleaned, old, dried gourd in the mud of a taro patch (that is, in the mud beneath a pond of water), and leaving it there for three or more days, the outer surface becomes quite black. I was not able to scrape off this black or to peel off the dyed outer portion of the rind. I put candle-wax on portions of one of the gourds and this partially blocked the black dye. I tried glue, but the stain produced by the action of the mud seeped under the glue. Obviously the gourds are stained black by emersion in a median which makes this stain. The design itself is produced by blocking the stain, or removing it."[6]

Concerning Brigham's explanation Emory further says: "You will notice that the designs consist of lines, many of them quite fine, and of triangles and small dots. Now if the gourds were stained according to Brigham's explanation, most of the glaze would have been scraped off except for very fine lines and dots and some thicker lines and some triangles. It does not seem to me to be practicable. Perhaps the glaze was put on in thin lines, etc. However, I believe the explanation given by an old Hawaiian woman of Niihau, — Makahonunaumu, over a year ago [1940] and a few days before her death will be borne out by experiment as true. The gourds were stained while green, — the outer skin is then quite soft. This skin is then removed by scraping over the part which is to carry the design. As the gourd dries it turns from a greenish-brown to orange-brown and hardens to the point where a knife can no longer be thrust through it."[7]

That the gourds were marked while green, before the removal

of the outer skin, is also stated by Thrum in a footnote to Fornander. He asserts, too, that this was sometimes done before the fruit was removed from the vine.[8]

This all concerns the process used for the Niihau method. The "pyrogravure method" may have been done by burning on the design as appears from a surface examination or it may have been a different form of staining done by some process similar to the descriptions of Ellis and McBryde.

Emory says of Ellis' account: "If Ellis is describing the smooth-surface stained gourds then he has made a mistake, for the wave and straight lines, etc., are in the natural color of the outer skin of the gourd and the rest is black. I believe that his drawing process, done with a piece of wood or stone, is a scraping process removing the soft outer skin of the fresh gourd just after the gourd has been stained entirely black by the infusion — which effects only the outer, tender skin. This then is removed by the scraping process over the part to cover the yellow design. The gourd is then put in the oven to be hardened by baking."[9]

The method described by McBryde to Bennet produced a light design on a dark background and does not apply to the "pyrogravure" gourds which always have a dark design on a light background. The Niihau type are almost always light on dark but occasionally the opposite effect is obtained See [Plate XII, C].

Whether McBryde's method was given him by a native informant or was his own independent interpretation it is impossible to tell.

Ellis' description mentions designs and finished products more like the Niihau type than the other. There is the possibility that he saw some Niihau stained gourds and then saw some gourds being stained in Hawaii and assumed the process he witnessed in operation produced the result with which he was familiar.

In short, the exact methods employed by Hawaiians to decorate their gourds are unknown but Greiner's statement that designs were "painted" on gourds is certainly erroneous.[10] Existing accounts are confusing and must eventually be straightened out by direct experimentation with green gourds. There were, no doubt,

at least two distinct processes, one used on Niihau and Kauai and the other on part of Hawaii. The Kohala district of Hawaii may have been the region where the "pyrogravure" method was practised for it was here that tattooing was done to a greater extent than elsewhere in this group. This artistic tendency may have included some gourds. The argument against this is that of all the numerous gourds found in caves of this region not one is decorated. Evidence also indicates that stained or decorated gourds were unknown in the southern Hawaii.[11]

Greiner has divided all designs found on Hawaiian gourds into four groups: Those similar to the meshes of a net, or interlocking ovoid figures; horizontal lines bordering rows of triangles, diamonds, or hexagons; circles; and tattoo or petroglyph designs placed irregularly on the gourd.[12] These four types still hold good for gourds decorated by the "Niihau method" which is probably all that Greiner ever saw, although she makes no mention of methods.

The designs of the "pyrogravure" gourds at Harvard cannot be so regularly classified. Mostly these designs are not so well executed, and the various units such as, circles, parallel lines, dots, triangles, and diamonds are sometimes inextricably mixed, as in the decorated hula drum [Plate XVI, C]. On the large trunk a good sized section of the surface is covered with concentric circles, connected by groups of parallel lines running at all sorts of angles. All the lines, both circular and straight, have irregular saw tooth edges [Plate IX, B]. None of the designs are enclosed in outlined areas like the meshes of a net — the most common fashion among the Niihau gourds. An area covered with a single repeated motif such as lozenges, dots, parallel lines, triangles, or lines forming a brick-work pattern will sometimes be outlined. But apparently this is an arbitrary limitation of the field covered and does not follow the meshes of a net or any other regular pattern.

The body of the water bottle decorated by this method [Plate II, C and D] is divided into nine roughly rectangular sections. Selecting one section at random and continuing from left to right

Decoration and Basketry

around the bottle the elements in each area are: three parallel rows of scallops, lozenge pattern, parallel horizontal lines with small triangles coming up from them like saw teeth, parallel vertical lines with short bent traverse marks making each line look like a row of interlocking crow's feet, parallel horizontal rows of interlocking triangles, parallel horizontal rows of saw tooth triangles, another of interlocking triangles, another of lozenges, and one of parallel horizontal zigzag lines. The small whistles, always decorated by this method, usually are ornamented with rows of parallel lines, both plain and zigzag, triangles and dots. Sometimes large areas are darkened, usually at the top and/or bottom of the whistle [Plate XVII, B and C]. The Salem specimen [Plate XVII, C and D] is unusual not only for the radiating base design but for the numerous dots which cover the entire surface. These dots are small cavities which have been filled with some white clay-like substance. This is the only instance of inlaying that I have found on Hawaiian gourds. The four pointed star on the base of another whistle [Plate XVIII, E] with the two domino figures and the dotted circles is also unusual. The only other specimens, besides those of the Harvard collection and the small whistles, decorated by the "pyrogravure method", is one rattle and two *kilu*. On the rattle, besides a large star on the bottom, there are several irregular stars [Plate XXXII, D to G], and near the handle a band of open triangles and a band of "X's". The *kilu* are decorated with triangles filled with dots [Plate XXII, C], and rows of triangles [Plate XXI, C].

Gourds decorated by the "Niihau method", particularly the water bottles, most commonly have the design outlined by the net mesh pattern. These designs have been described in some detail by Greiner.[13] The net meshes are not always the same shape [Plates XXIX to XXXI] but the principal is the same. The mesh units contain various combinations of straight and zigzag parallel lines [Plates XXIX to XXXI] sometimes with triangles [Plate XXX, D] or half circles [Plate XXXIII, E to G] on one or both sides. Some are filled with six pointed stars [Plate XXXI, A], small dots bisected, trisected, or quartered by short lines [Plate

XXXIII, F and H], hourglass figures [Plate XXX, C], and irregular lozenges with lines protruding from the ends [Plate XXX, B]. On Niihau bowls the net mesh is sometimes used [Plate XXX, B], but horizontal bands containing triangles, lozenges, and hourglasses in various combinations seem to have been preferred [Plates XII, A, C, and F]. One bowl has around the rim two bands of chevrons, pointing in opposite directions [Plate XII, A]. Another has the rim bordered with a band of "W" shaped figures resting on their sides. Single motifs unconnected with banding or net mesh patterns are rare, but one bowl [Plates XII, D; XXXIII, A to D] has four different figures on its surface. The bowl is probably comparatively late. One of the figures [Plate XXXIII, C] looks like a shield with a plant growing from its top — possibly this represents a pineapple. The other three [Plates XXXIII, A, B, D] are apparently taken from different trees and other plants, or in the case of A and D, possibly a stand or rack of some kind. In general, symbolical or natural representations are rare in Hawaiian art. Greiner mentions and figures one gourd design following a floral pattern but this is rare and probably late.[14] In several water bottles having the net pattern, the upper meshes contain stars and the lower meshes, zigzag lines [Plate I, E, and F]. As the position of the stars and the lines is consistent through several specimens, it may be that the designer intended a representation of the heavens with the waters beneath them, possibly having some connection with the Hawaiian creation myth featuring a gourd (Cf. p. 71).

The design on the bottoms of the water bottles, sometimes formed by the bases of the mesh triangles on the side are either quadrilateral, circular, pentagonal, or polygonal. Sometimes these bottom designs are perfectly plain but more often they are elaborated in some way [Plates XXV to XXVII]. Maltese crosses [Plate XXV, D and E], elaborated corners [Plate XXV, C, Plate XXVII, B], and notched sides [Plate XXVI, A] vary the patterns of some basically square types. The only base of concentric circles occurs on the single specimen of a water bottle with "pyrogravure" ornamentation [Plate XXVI, C]. One unusual type

is a circle crossed by two straight lines which intersect near the center. In one of the resulting sectors of the circle is a petroglyph of what appears to be a human figure holding a club [Plate XXVI, D]. Two of the quadrilateral bases are partially filled with other designs [Plate XXVII, B and C]. Another is so small that the first four triangles which would normally project up the sides of the bottle are wholly on the bottom and form a part of the bottom design [Plate XXVII, A]. Around the necks of water bottles, above the triangles, occur designs somewhat similar to those on the bottoms [Plate XXVII]. The shapes are the same but they are usually somewhat more elaborate. One incorporates a fan motif [Plate XXVIII, A] and another has the more familiar stars.

Although little has been written about methodology in the ornamentation of New Zealand gourds, and their use has long since been abandoned in that area, it is obvious from an examination of the existing specimens that the technique employed has little in common with the Hawaiian methods. The New Zealand method was apparently to cut the design into the surface of the gourd with some sharp instrument. There may have been two types of cutting, one making a design in low relief with broad depressions, the other simply outlining the design with sharply cut grooves.

The designs on New Zealand gourds are of the same intricate curvilinear type as Maori carvings in wood [Plates IV, V, XIV]. One water bottle [Plate IV, D] shows this carving in a very degenerate form. Phillips in a paper on the design element called *koru*, which is a curving stalk with a bulb on one end, mentions this design on carved gourd containers called *ipu whakairo*.[15] He says that patterns found on old carved gourds preserved in museums are probably traditional. One specimen he mentions but does not illustrate has the surface divided into symmetrical areas by straight lines and the areas than filled with *koru* designs. Regional differences in the *koru* designs were also found. Of another old specimen Phillipps writes: "A large oval uncarved area marks the resting-point below the vessel. Halfway between the margin of this oval and the upper edge a curcular band runs round the *ipu*,

koru designs emanating from it above and below. Two features stand out relegating this *ipu* to an important position in the history of Maori design. These are, firstly a number of small circular areas used to give greater effect to the *koru*, and, secondly, bands of carved plaiting or basketry. The circular areas are not necessarily degenerate spirals, but may be bulbs of the *koru* devoid of their stalks."[16]

Nettings

In the Hawaiian Islands gourds were hung in the house, out of doors, or on a traveling stick, by suspension cords or nets called *koko*. Any one who doubts that a detailed study of these nets required a book by itself has only to read Stokes' paper.[17] There is no need here to repeat all the numerous varieties with their peculiarities of hitches, knots, and turns. Suffice to say that different attachments were required for differently shaped gourds of different uses. The net that held a traveling trunk efficiently would not keep a canoe water bottle in place, and the single cord from which an hourglass-shaped water bottle hung was inadequate to suspend a food bowl. Hawaiian nets were beautifully made and their workmanship attests the high skill of pre-European workers. Some bowls were suspended by cords passed through several holes and knotted at the ends. The principal materials used were coconut cord and sennit, and cord made from *olona (Touchardia latifolia)*. For traveling a stick called an *auamo* was carried across a man's shoulder and gourds slung from either end of it [Plate VIII].

In the Marquesas gourds were supported and protected by a network of cords similar to the Hawaiian *koko* but inferior in workmanship. Their manufacture has long since been discontinued even as the Hawaiians.[18] Suspension devices of various kinds were employed in some of the other island groups where gourd containers were utilized, but little is known about them and evidence indicates that they were considerably less elaborate than the Hawaiian type.

Basketry

The use of basketry for the protection of gourds is peculiar to the Hawaiian Islands and New Zealand in Polynesia.[19] The Hawaiian baskets are superb. They were woven from the tendrils of the *ieie* (*Freycinetia arnotti*) and so snugly did they fit the gourds that the two seem almost to be one wall. There is no looseness, no play, and a thin knife cannot be forced between the gourd and the basketry without damaging them. The art of making these baskets has long since been lost but numerous specimens are preserved in various museums [Plates IX, XIII]. It is said that covered gourds of this type, called *hinai poepoe*, were especially used for holding highly valued objects — primitive strong boxes.[20] So well made were the baskets that if the gourds became accidentally broken the baskets were used for many years more as general utility containers. It is asserted that gourd bottles were sometimes covered in the same way but this must have been rare.[21]

In New Zealand the large gourds mounted on legs and used for storing cooked pigeons, were encased in basketry [Plate VII]. This was not nearly as fine as the Hawaiian type and fitted the gourd somewhat more loosely.

Repairing

Gourds broken, but not too badly, were mended by drilling holes a few millimeters apart on each side of the break and neatly drawing the two parts together with *olona* cord [Plate XIII, E].

CHAPTER VII
MYTHS, TALES, AND PROVERBS

We began this book by quoting the "Prayer of the Gourd" or Pule Ipu. Following are some examples selected from the rich folklore and mythology of the islands as well as references to the gourd in prayers, proverbs, riddles, and the chants accompanying string figures.

The importance of gourds to the Polynesians is no better indicated than by the numerous magical, allegorical, and legendary references to them in the myths and tales of the people.

A creation myth of the Hawaiians explains the universe as developing from a gourd. The gourd was the offering of Wakea (Vast-expanse) and Papa (Rock). The gourd was divided into two parts. The upper part, or cover, was taken by its mother and thrown upwards where it became the heavens. The sun, moon, and stars were produced from the pulp and seeds, while the bowl became the earth and the waters thereon.[1]

When the world was new and becoming settled, duties were given to all the plants, animals, and inanimate objects; and it was at this time that it came to pass that gourds, coconuts, and joints of bamboo were destined to hold water for mankind so that it could be conveniently carried everywhere. The gourd was also singled out particularly to hold sea water as distinguished from fresh water.[2]

Polynesians, too, have their myth of a great deluge, although this may be taken over by the natives after the introduction of Christianity. Among other things it is said that after the waters subsided "gourds spread out over the land."[3]

The importance of gourds in the religious and social activities of the Polynesians, and the Hawaiians particularly, can hardly be overestimated. In the tombs and places of worship of the Hawaiians, where figures of the gods were set up, broken gourds were found along with other refuse where offerings had been made.[4] Polynesians had spirits who were their "familiars" and

who must be fed and cared for like oneself. If a person was eating, a small gourd bowl of poi or other food might be given to the spirit to keep it powerful and happy.[5] These spirits were entirely private, and it was necessary for any individual desiring one to create it by obtaining the body of a relative, friend, or child and keep it in his house. The spirit stayed with the body, and was given a permanent home by cleaning the bones and tying them, with the hair, into a bundle. The spirit's keeper then supplied it with clothing, food, kava, gourd containers, and other necessities of life. As the spirit was fostered it gradually became stronger and of more help to the keeper. Once a spirit was created, however, it was necessary that it be supported.[6]

Gourds and coconuts, holding food and water, were placed by the resting places of the dead in the Marquesas. Native priests also found the gourd most useful for devinating purposes in several of the island groups. For example, in the Hawaiian Islands, it was believed that a person could be prayed to death by someone who disliked him. If it was thought by friends and relatives that the death of any individual was caused in this way, they might hire a *kahuna*, or native priest, to locate the guilty person. After a great deal of ceremony a gourd and some *kukui* nuts were struck against a stone and from the way the pieces scattered the priest could point out the locality of whoever caused the death. A later part of the same proceedings involved building a fireplace and displaying a gourd for ornamentation on each corner of it.[7] Prognostication by observing the direction in which the fragments of a broken gourd pointed was also practiced to some extent in Tahiti.[8] In Samoa after a youth was tattooed a water gourd was broken. If the stopper of the gourd could not be found the youth would die as a result of the operation.[9]

One class of unscrupulous Hawaiian magicians found gourds convenient for imprisoning the souls of living people which they had the power to see and catch. This was an alternative to squeezing them to death, and was much more profitable for the soul once imprisoned could be used to blackmail the owner

because if the soul was once squeezed to death the body would sicken and die or if he paid up it could be released.[10]

Danger was foretold by a dream in which a water gourd broke and the water ran over some rubbish. This was interpreted that blood would be spilled the following day and was considered a very ill omen.[11]

Gourds entered incidentally into stories and legends many times. There is the tale of the ghost who wandered aimlessly from place to place with its gourd thrown over its shoulder.[12] And occurrences like that in the following two lines of a chant are common:

> "Of the child with the round water gourd,
> Of the women with the water gourd — there
> they lived."[13]

In Tahiti a person doomed to be killed was referred to as a "broken calabash".[14]

Beckwith speaks of the term "Mo-i" as applied to a high chief as follows:

"The name is made up of two words, thus *mo* is a "gourd', *i* means 'to speak', hence 'a gourd to contain words; meaning that the important decisions of the government are contained within him. Hence the old Hawaiians called the high chief *mo'i* as meaning one who speaks for all."[15]

Although there is no question about *i* meaning "to speak", I can find no other authority for the word *mo* meaning a "gourd". Andrews makes no mention of this meaning but does say "*Mo* is a prefix to many words, but the meaning is not very important."[16]

In the Tahitian legend of the eel Fa'arava-ia-nu'u there figures a water gourd in which half an eel was kept;[17] and in the Maori tale of how Rongo brought the "Arawa" root to New Zealand, water brought in "the gourd of the *hue*" was set before him.[18] A Maori saying with an element of sarcasm refers to the gourd when it says "Bravo! children, smashing your mother's calabashes."[19]

Reminiscent of the famous Grecian myth of Odysseus and the

bag of winds given him by the god Aeolus are the various Hawaiian folk tales involving the winds imprisoned in a gourd.[20] One of the best known of these is that of Paka'a. Paka'a's mother was La'a-ma'oma'o, who is also sometimes identified as the goddess or god of the winds. She presented her son with a finely polished gourd, as one version says, or with a gourd covered with basket work according to another. This gourd contained the winds and also the bones of his grandmother Loa, who controlled them, although another version says the bones of his mother. He was told that if becalmed be could summon any wind he wished which would carry him safely to land. Paka'a eventually became the favorite of a king of Hawaii and had charge of all the king's personal goods as well as the sailing of his canoe. Here his control of the winds stood him in good stead, and although he lost favor and was banished for a time the incompetence of his successors opened the way for his return.

Another of the wind gourd stories figures Maui, a legendary hero, as the chief character. In this tale, the winds were kept in a gourd and controlled by an old priest who lived in the Waipo valley of the island of Hawaii. Maui had made a large kite of tapa with a cord of the *olona* plant, but he could not find wind enough to fly it. Finally he remembered the man who controlled the winds. Maui went to the priest and asked him to let some of the winds escape. This was done and some very strong winds were let forth. Maui rejoiced at his kite flying and kept calling for stronger and stronger winds. Each time he called for more wind the priest lifted the cover of the wind gourd a little higher. Finally the gale was so strong that the kite string parted and the kite was lifted over the volcanoes to the other side of the island. Maui was angry but after he recovered his kite he was more careful about calling on the winds to aid him.

In Hawaiian folktales there are numerous incidents of cleaning the bones of the dead and keeping them in gourds. This has already been mentioned where the bones of the wind goddess were kept in the gourd with the winds she had controlled during her lifetime. Several similar occurrences in the story of

Myths, Tales, and Proverbs

Lonoikamakahiki, throw additional light on this treatment of the dead.[21] Often it is the bones of chiefs that are preserved in this way,[22] but the same treatment was also apparently given to enemies on occasion.[23]

A tale widespread in Polynesia is that of a man who is lured into marrying a demon woman, who could change herself into numerous forms and was a cannibal. Not knowing his wife's nature until after he is in her power, he effects his escape, after many breath-taking adventures, by asking his wife to obtain some cold water for him. She agrees, but before giving her his water gourd he pierces it with holes. While she wastes considerable time and energy attempting to fill the gourd her husband manages to escape.[24]

The punctured water gourd is also used as a joke in the Tuamotuan legend of the hero Honoi'ura. The hero pierced his water gourd and then sent his brother Tuma to fill it, as a practical joke. Tuma on seeing that the gourd leaked examined it and found that the hole had just been made. While Tuma had been endeavouring to dip water three beautiful girls appeared and stood laughing at him. When he discovered this he was greatly embarrassed, and was still more confused when the girls improvised a song about the man who stooped low to dip up water with a punctured gourd. Tuma became so angry with their taunting that he took the gourd in his hand and returned to Hono'-ura and smashed it over his brother's head.[25]

Another part of the story of Hono'ura, speaks of his use of a magic gourd. This magical ancestral gourd, named Te-pori (fatness) was brought with him from Ta'aroa, his mountain home. Within the gourd was a supply of cold mist called Dew of Ta-aroa. Hono'-ura possessed a spirit guide who directed him to let the mist escape over the sea, and to this day the mist can still be seen around the region where it was let out but is unknown around any other of the Taumotu Islands.[26]

The god Ta'aroa, in the Tahitian legend of Pai, thus concealed from its mother's enemies a child, who was born prematurely in a clod:

"So Ta'aroa sent his messengers for a large green gourd from a vine in his garden, and opening the stalk end he excavated a space within, and placed the clod there. Then he closed the gourd tightly and put it in a basket, which was suspended upon the ridgepole of his canoe shed, facing an ever calm sea; and there the child lived upon the pulp in the gourd safe from the hands of foes. When the food in the gourd was consumed the child cried out lustily, and the gods knew that it was time to take him out. So they broke open the great gourd, and there appeared a fine young lad, who exclaimed:

'Now I can see! It was thick darkness in that gourd in which I have been living.' And he fell fast asleep without clothes."[27]

Hawaiian legend accounts for the origin of the bitter gourd by having the vine grow from the navel of a chiefess who died and was buried in a cave. The vine found its way to the garden of a certain chief and there grew a handsome gourd. The chief discovered the fruit and thumped it to test its ripeness, which made the spirit of the gourd complain to a priest in a dream. The priest and chief followed the vine to its source and thereafter the gourd was treated respectfully.[28]

An unintelligible myth of how the gourd was created is found also in Easter Island.[29] In the Hawaiian tale of the fight between Kahakaloa and Kawelo a gourd is used as a head piece — but not successfully. The two warriors fought for some time until finally Kawelo was knocked down by his rival. Kahakaloa at this critical moment decided to go and get himself some food before killing Kawelo. He went to the top of a nearby hill and there cooked and ate a chicken. After finishing his meal he took the empty gourd bowl, placed it on his head, and proceeded down the hill. Kamalama, a friend of Kawelo, saw the strangely attired warrior approaching and remarked to Kawelo: Here comes a bald-headed man down the hill; his forehead is awfully shiny."

Kahakaloa arrived and discovered Kawelo sitting up. Thereupon another spectator, Kaehuikiawakea, said to Kahakaloa:

"Kawelo has come to life again, therefore you a soldier will be killed. I cannot be killed for I am a runner." Kawelo arose and prepared to do battle with his enemy. Kahakaloa then assumed the defensive and Kawelo raised his club and bashed the gourd down over Kahakaloa's eyes. Before his adversary could remove the obstruction, Kawelo struck once again with his club and killed him.[31]

According to Hawaiian story, in the days when the world was new and things were not yet stabilized, the heavens fell down and all the people had to crawl about. Slowly the plants grew and raised the heavens a little above the earth. Then one day a man came along and offered to push up the heavens for a drink of water from a woman's gourd. He received the water and the heavens were replaced where they have remained ever since.[31]

In an Easter Island tale, called "The Bad Spirit Raeraehou and the Good Spirit Matamata-pea", the bad spirit masquerading as a man entices a girl to the mountain top where he is about to cook her. The good spirit helps the girl to escape and she hides herself in a hole. An old woman saw her and offered to give her sweet potatoes to eat. The old woman lowered the sweet potatoes in a gourd; and fed in this way, the girl remained in the hole while the bad spirit searched for her. Finally he got tired and the girl went and stayed at a *koro* house at Mataveri. The spirit came to the house and was killed by the people. His blood spouted out and became a shell. The girl forgot about the incident; but the following year, she lifted a big shell she found on the shore, and as she did it a wave came up, which took the girl away so that she was never seen again.[32]

Concerning the origin of the obsidian spear heads characteristic of Easter Island, there are two stories both indicating that the gourd spear heads were used in mock warfare before the obsidian heads were discovered. The first is about three brothers whose father was dead, and whose uncle had twenty children. The three boys went surf riding with their twenty cousins and afterwards they all warmed themselves in the sun. After they were warm the cousins suggested that a sham battle be fought with gourd tipped

spears. All were agreeable but the three brothers found themselves on one side with their twenty cousins on the other. After fighting for some time the cousins became angry and attacked the three brothers with stones, driving them home. The same procedure was followed for the two succeeding days. After the third incident one of the brothers accidentally cut his hand on a piece of obsidian and said to his brothers; "Tomorrow we shall kill them." Thereupon he chipped twenty pieces of obsidian, tied them to sticks and hid them along the way they always retreated. The next day they killed nineteen of their cousins one by one, and later went to their uncle's house and killed him.[33]

Thomson gives a different story to account for the invention of obsidian spear heads. Spears were improvised with heads made of the sharp edges of the calabash, but they proved inefficient weapons and did little execution. One warring chief, who had made little progress against his enemies, accidentally stepped on a piece of obsidian and cut his foot. The harder material was substituted for the gourd points. The new weapon was quite effective, and until the new material became well known the discoverer and his people swept everything before them.[34] This story with its implication that the gourd points were once previously used as weapons sounds the more improbable of the two.

Still another legend tells how thirty brothers and thirty other men, "practiced fighting every day with sham darts tipped with a piece of calabash."[35]

From a Marquesan myth there appears another type of magic gourd. The story concerns the birth and adventures of the god Toho-tika, who was a native of the island of Hiva Oa, but who had gone to Nuku Hiva. The people of Hiva Oa sent a chief named Kopa in search of him, but Tohe-tika heard of Kopa's coming, and to evade him, secretly returned to Hiva Oa before Kopa arrived at Nuku Hiva. When Kopa landed, he inquired of a woman as to the whereabouts of Tohe-tika. In answer she put a piece of yam into a calabash, poured water over it and then passed it to him.

"In the calabash Kopa saw reflected the picture of his own sunny land, and he could plainly see there the one for whom he

was searching, hiding in Topua under a piece of cloth an old woman was making. Kopa returned to Hiva Oa, found things exactly as they had been reflected in the water, and with the help of the old woman succeeded in putting the notorious Tohe-tika into a sack." In this way Kopa carried him back to his own valley.[36]

In New Zealand the name Pu-te-hue was used, sometimes apparently as a name for the personification of the gourd plant and at other times as a minor deity who created the gourd. One version says the gourd was given by Pu-te-hue to the Toi tribe who were the first possessors of the plant.[37]

Gourds are rarely mentioned in the legends of Samoa and Tonga, and when they do occur it is usually in a very casual way. A typical example is the mentioning of a gourd of oil in one of the Tongan legends.[38]

The Polynesians, like many other peoples, entertained themselves with string figures, or "cats cradle" as we call the amusement. Many of these string figures were accompanied by chants which were recited as the figures developed.

Two of the Hawaiian string figures are named, "water gourd of Kupoloula".[39] One of these tells how Kupoloula, a chief of Niihau, drank the water of life of Kane, which was in a gourd hidden at the botton of a hole, six months' journey toward the rising sun. Another chant tells of a man holding his gourd in his teeth while he descends a steep path down a precipice.[40] In another a conversation between the *elepaio* bird and the *io* hawk is recorded.

> "'Oh, io! Oh, io!
> The man has hit me with a stone!'
> 'Whose fault is it?'
> 'It's my fault.
> Pecking holes in the man's water gourd.'
> 'Your fault indeed. You will be tried
> at our court of birds.'"[41]

In other string figure chants from Hawaii, the Marquesas, and

Society Islands, poi, flower, and kava bowls are mentioned which may or may not have been gourds.[42]

The language of the Polynesians was rich in all that makes for good oratory. They also had many proverbs, riddles, and sayings of various kinds. For the most part these are unrecorded, but for the Hawaiian Islands, Judd has accumulated a formidable list.[43] Gourds and "calabashes" are mentioned in many of these, but there is no point in repeating any here beyond a few to serve as examples.

The saying "The gourd of wisdom" refers to "a wise man". To "nip the young shoot of the gourd vine while it is young" is to "destroy the infant". One proverb, which is similar to one of the string figure chants (Cf. p. 79) goes "Oh hawk! I have been hit by a man's stone. 'Whose fault is it?' Is it my fault, for making a hole in a man's water gourd?' " This is interpreted as meaning "No one is hurt for doing the right thing". If one says "Bring the large gourd, leave the small gourd" it means "always select the best."

One of the sayings about places is "From Hanamaulu comes the empty gourd" meaning that from Hanamaulu come ignorant or stingy people. The prayer of a becalmed sailor which seems to appeal to the gourd holding the wind goes "Blow here, blow here, ye wind of Hilo, leave the little calabash, give me the big one."

The following are riddles: "A gourd with a cover, a gourd with a cover till the heavens are reached." The answer to this is "bamboo" as each joint of bamboo has a cover. "My little man with the long bowels" is a gourd holding fish lines. The answer to the riddle "My lopsided gourd, hanging on a cliff" is "the ear".

As some of the sayings or riddles depend on a play on words or a trick of speech they lose a good deal or all of their point when translated into another language.

CHAPTER VIII
SUMMARY AND CONCLUSIONS

From the uses of gourds set forth in the preceding chapters and the chapter on myths and legends it will be readily seen that gourds were of more economic importance in some islands and groups than in others. This is due partly to ecological conditions, since in some areas the gourd has more rivals than in others, and partly, apparently, to the preference of the inhabitants.

As we have already noted, gourds do not grow on coral islands, so that Tongareva, Pukapuka, Rakahanga, Tokelau, and the Ellice group do not concern us. Here gourds did not grow, and apparently were not known traditionally. In the Tuamotu Archaepelago, also made up of coral islands, gourds were not grown, but the tradition of them appears in several tales collected in the group (see p. 75). On Mangareva, though, a high island, the plant did not exist, but in one story collected there by Buck occurs the passage, "The poisonous bitterness of the gourd has entered deep within."[1]

Omitting, then, those parts of Polynesia where the gourd was lacking or played an inconsequential part in the culture of the people, the areas where the plant was of real importance, economically, as well as in religion, music, and folklore may be summarized for comparative purposes.

Tonga Islands

Here gourds were relatively unimportant. One use only, as an oil container, is recorded. An occasional reference is found in the myths and legends and Hornell describes a string figure from here called an *ipu sioata*.[2]

Samoa Islands

Gourds were also unimportant in the Samoa group, where bamboo and coconuts were preferred. Only two uses are recorded, for holding water and oil. Gourds are almost never

mentioned by writers and they are conspicuous by their absence in the legends.

Marquesas Islands

Only three uses, two types of containers and a rat guard, are recorded for the Marquesas. Here the large variety of coconut peculiar to these islands definitely favored these for containers, and joints of bamboo were also extensively used. Gourds had their place, however, and were noted by Lisiansky in use about the households.[3] Gourds were probably somewhat more important than is indicated by the small number of use categories. They are frequently mentioned as the containers for offerings hanging beside the dead, and they also figure in the folktales.

Society Islands

Here gourds were used only as water bottles and other containers of different kinds, but they had many rivals, especially wood, bamboo, and coconuts. No other uses can be found, although Henry assumes that any uses they had would be well known.[4] The implication is that they were not favoured as much as the other materials and were relatively unimportant. Only five different uses have been found but here again it is probable that there were a few more. Gourds are mentioned occasionally in the folklore (see p. 76).

Austral Islands

This group exhibits the same number of uses as the Society Islands, all five being as sorts of container. An interesting point to be noted is the cultivation and use of the plant here down to at least 1922.[5] This late survival in the face of European utensils is no doubt due to the group being off the beaten track and seldom visited. No legends or mythological material containing references to gourds have been found for this group.

Cook Islands

Although gourds were used only as water bottles in these

islands they were important for this purpose.[6] Possibly different varieties were peculiar to the various islands within the group. The plant is sometimes mentiond in mythology and folklore but this is rare.

Easter Island

Far to the east of all the other Polynesians the Easter Islanders lived in watery isolation. The only containers known to these people were gourds which at one time grew wild about the island in great profusion.[7] Thirteen uses have been recorded for this tiny island, and the culture of these people was badly depleted before it could be adequately studied, it is highly probable that there were many more originally, since other usable materials were rare or non-existent. There is no evidence that gourds ever served as an art medium, but they occur in the myths and legends with a fair amount of frequency.

New Zealand

In New Zealand the gourd was limited by the climate. As the plant would grow only in the warm northern part, the people of the rigorous south were forced to use less suitable material for their purposes. Unlike Hawaii the fruit of *Lagenaria* in this area was an important source of food and was consumed in enormous quantities. The plant was propagated by argicultural methods and was planted and harvested with a certain amount of ritual (see pp. 13 ff).

The total number of uses recorded for this area is eleven, and included some containers and musical instruments as well as a number of other uses. The most important container was the large gourd placed on legs and used for preserving birds in their own fat to be used at feasts and at times when fresh food was not plentiful. Bowls and water containers were sometimes ornamented with carved designs. The mention of gourds in myths and legends occurs but is not common.

Hawaii

Not only in pre-European days but even in the early historical

period, gourds were highly valued and were of great utility in the Hawaiian Islands. The extraordinary size of the giant variety of *Lagenaria* which was peculiar to these islands gave the Hawaiians a far larger natural container than any possessed by other Polynesians.

All the earlier historians of the islands comment on the prominence of gourds, and the multiplicity of their uses.[8] The lack of pottery, metal, and glass was compensated for by this fruit with its hard, light, waterproof shell. As wells were rare in these islands, the gourds provided the natives with perfect containers for transporting their water from natural springs to their homes.

The esteem in which containers of this fruit were held is indicated by the presentation gift to King Kalakaua in 1886 on his fiftieth birthday. This included many gourd vases, cups, and bowls; and one account says: "Amongst the hundreds of these articles presented to Kalakaua were some of very ancient make. Of these some were of gourd shells, ornamented with checkered designs of purely native origin."[9]

Besides water containers, Hawaiians also needed considerable storage space for the fermentation of poi after its preparation.[10] This important food was made in large quantities and then stored for fermentation in the big containers made from giant gourds.

On several occasions gourd fragments have been found on archaeological sites. On the desolate island of Kahoolawe, McAllister found gourd remains in bundle offerings collected at the Kamohio shrine as well as two complete cups.[11] At two sites on the uninhabited island of Nihoa, Emory found fragments of gourds.[12] He concludes that the large stone jars found only on Nihoa and Necker Islands were probably for the storage of water and were produced only because of a lack of wood and gourds.[13] He goes on to say that: "The parts of gourds found on Nihoa suggest that the gourd plants . . . may have been introduced and cultivated on Nihoa. However, any people able to reach the islands are unlikely to have made the stone vessels at a period when they possessed gourds."[14]

The efficiency of gourds for transporting large quantities of

water is well illustrated by the account of Captain Dixon. He tells how he and Captain Portlock in the ships *Queen Charlotte* and *King George* anchored in Waialae Bay, Oahu, for four days exchanging nails for "calabashes" of water. He writes, "Thus in this very singular, and I may venture to say, unprecedented manner, were both ships compleatly supplied with water..."[15] To supply two ships with water must have required an enormous number of gourds, and to accomplish the feat in four days must have taken the efforts of a large crew of Hawaiians as well as every sailor available.

Referring to Table I we find that gourds served thirty-six different uses in the Hawaiian Islands. Of these, thirteen are as containers, four liquid and nine dry, five are as musical instruments, and eighteen are miscellaneous uses of a wide variety. I think there is little doubt that many other uses have been lost for the possibilities are enormous. By the decoration of some of the containers, gourds take their place with wood, tapa, basketry, and featherwork, as one of the important art mediums for this group. Their uses in religious ceremonies and their mention in mythological stories and folktales have been discussed only briefly (Chapter VII). The use of gourds as a medium for artistic expression and the frequency of their occurrence in the myths and tales of the people, together with their many utilatarian uses provided a real insight to their importance in Hawaiian culture.

Conclusions

It is evident that the gourd was economically one of the most important plants in Polynesia. It is also evident that it was of far greater importance in some island groups than in others. Summarizing the evidence, the gourd attained its greatest worth in the native culture in marginal Polynesia, particularly the Hawaiian Islands, Easter Island, and New Zealand. It was less used in Central Polynesia — the Society, Cook, and Austral Islands, and the Marquesas; while in Western Polynesia — Samoa and Tonga — it was relatively unimportant. Of all these groups it was outstanding in Hawaii.

As an artistic medium, so far is known, the gourd was used only in Hawaii and New Zealand, and it was also only in these two regions that it was reinforced with basketry.

Besides the various categories of objects manufactured from gourds, their importance in medicine, as a source of literary inspiration, their use in mantic practices, and the parts attributed to them in creation and other myths have been brought out. They are frequently mentioned in folklore, stories, and the chants accompanying string figures.

Certain magical practices have arisen around the methods of planting, caring for growing plants, and harvesting.

The Polynesians also, though this could be disputed, may have been responsible for introducing this valuable plant to South America where it has not only been found archaeologically, but, as illustrated by the beautifully silver mounted mate gourds for example, is an economically important plant throughout many parts of Central and South America.

After serving its period of usefulness to man, the gourd, as a culturally important element in Polynesia, is no more. Except for specimens in museums, — gone are the *hula* drums, the lovers' whistles, and the "Niihau calabashes". No more do the Maori feast on roasted pigeons taken from their own fat in the great preserving gourds. We look at an object in a case and strain the imagination to see it in its own setting. But as year swiftly follows year, the once living culture of the Polynesians of old recedes farther from the objects which it created into the background of antiquity.

NOTES AND REFERENCES

References refer to the full names and titles given in the Bibliography. In cases where more than one work of an author is referred to the date of publication is given after the author's name. In some cases authors have published more than one work in a year and these are identified by a letter immediately following the date, as "Best (1925c) 36". The page number follows the date, and volume numbers of works of more than one volume are indicated by roman numerals.

CHAPTER I
[1] Malo, 121-122. Also partially in Handy (1933), 59-60 and Beckwith (1940) 33.
[2] Ibid., 119-23; Handy (1927), 219.
[3] Dixon (1932, 1934).
[4] Te Rangi Hiroa (1938b), 304-116.
[5] Burrows (1938).
[6] Handy (1927).

CHAPTER II
[1] Brigham (1908), 139.
[2] Wilder, 103.
[3] Handy (1940), 207, and Eames and St. John (1943)
[4] Hillebrand.
[5] Compare the statements by Stubbs, 34; Brigham (1908), 137 or 8, 141; Bryan (1915), 61, 209; Bishop Museum Handbook, 31; Bryan (1938), 23, etc.
[6] Personal correspondence with Dr. Harold St. John, University of Hawaii. See also Handy (1940), 207.
[7] Handy (1940), 207-208.
[8] Roberts, 52.
[9] Fornander & Thrum, III, 168.
[10] Compare the statements of Malo, 161; Bryan (1915), 61, 209; Stubbs, 34; Brigham (1908), 137, 139, 141; Roberts, 52. It is hoped that some day a botanist will make an intensive study of the varieties of this species in the Pacific.
[11] See, for example, Bishop (1916), 37; Bryan (1915), 59; Brown (1931), 124.
[12] Handy (1940), 208-211; Best (1925b), 129-134.
[13] Handy (1940), 211.
[14] Ibid., 209.

[15] Ibid.
[16] Ibid., Roberts, 52.
[17] Handy (1940), 209.
[18] Fornander & Thrum, III, 166-168; Roberts, 52, Handy (1940), 208,210.
[19] Cook (1785), III, 150.
[20] Handy (1940), 210.
[21] Ibid., 209.
[22] Best (1925b),69.
[23] Ibid., 130.
[24] Ibid.
[25] Ibid., 132.
[26] Ibid., 133.
[27] Ibid., 131.
[28] Ibid., 129 for native text.
[29] Ibid., 133 for native text.
[30] Ibid., 130.
[31] Ibid., 131.
[32] Ibid., 133.
[33] Ibid., 132.
[34] Ibid., 131.
[35] Ibid., 133.
[36] Ibid.
[37] Ibid.
[38] Ibid., 131.
[39] Metraux, 157.
[40] LaPerouse, I, 73, 78.
[41] Gonzalez, 123; Cook (1777), I,288.
[42] Handy (1940), 210.
[43] Bryan (1915), 61; Malo, 161.
[44] Handy (1940), 210.
[45] Bryan (1915), 61.
[46] Malo, 162.
[47] Best (1925b), 131.
[48] Beaglehole (1940), 57; Andersen (1928), 89.
[49] Best (1925b), 130.
[50] Bryan (1915), 79; Stubbs, 34; Bishop Handbook, 61: Handy, Pukui, and Livermore, 15-16.

CHAPTER III

[1] Speck (1940a), 10.
[2] Brigham (1908), 137
[3] The Hawaiian name for *Lagenaria vulgaris* is *ipu*. Gourd containers are also *ipu* as are those of wood. See Appendix for list of native names.
[4] Best (1924), I, 424.
[5] Handy (1923, 66; Linton, 293.
[6] Linton, 355.
[7] Ibid., 357.
[8] Ibid.
[9] Metraux, 157.
[10] Ibid.
[11] Aitken, 38.
[12] Bishop, (1916), 15.
[13] Bishop Handbook, 31; Brigham, (1908), 142; Bryan (1938), 24.
[14] Bishop Handbook, 31; Brigham (1906), 63.
[15] Ellis (1827), 376.
[16] Bishop (1940), 14; Bryan (1938,) 23; Bishop Hand-

book, 31; Bishop (1916), 15.

[17] Bryan (1938), 23; Brigham (1906), 19.

[18] Stokes (1906), 148.

[19] Bishop Handbook, 31; Stokes (1906), 148.

[20] Bishop Handbook, 31.

[21] The catalogue numbers and dates of accession of the Salem specimens are as follows: E5,312, before 1821; E5,313, before 1860; E22,025; E5,311, 1803; E19,623, Goodale collection; E5,310, 1949; E18,650, 1843.

[22] The calalogue numbers and significant sources and dates of accession are as follows: 37,669, 1885; 37,670, 1885; D-2714; 312, Massachusetts Historical Society, 1867; 48,438, American Antiquarian Society, 1895; 1254, Boston Marine Society, 1869; D-2940; D-2938; 53,569, Boston Museum, 1899. These Harvard dates while not so early as those of the Salem specimens are significant because some are the gifts of other institutions. There is no way of telling how long these donor institutions had the specimens in their collections before giving them to Harvard.

[23] Mrs. Bishop's number 70. See Bishop (1940), 84.

[24] Brigham (1908), 141.

[25] Emerson (1906) MSS Cat.

[26] Calalogue number E11, 955. Height 9", diameter 6".

[27] Bishop (1940), 83-84, Nos. 69,321. No. 69, height 8 ¼, diameter 5". No. 321. Height 9 ½", diameter 6 ¼".

[28] Bishop (1940), 84.

[29] Stokes, (1906), 148, says he was unable to learn any specific name for the sling or *aha* of these gourds. He goes on to remark that "since only two (Nos. 3877 and 3880) out of five specimens in the collection have *aha* exactly similar, the probabilities are that each individual followed his own taste in cording."

[30] Best (1924b), I, 396.

[31] Hamilton, 405.

[32] Te Rangi Hiroa (1927), 73.

[33] Best (1924b) I,424.

[34] Handy (1923), 66.

[35] Linton, 355.

[36] Handy (1923), 121.

[37] Thomson, 456; Cooke, 705.

[38] Metraux, 157.

[39] Thomson, 535.

[40] Henry (1928), 551.

[41] Ellis (1831), Vol. I, p. 191.
[42] Te Rangi Hiroa (1927), 48.
[43] Ibid
[44] Aitken, 107.
[45] Ibid., pl. V.
[46] Bishop (1940), 83.
[47] Salem catalogue number 315.
[48] Harvard catalogue number 315.
[49] McAllister (1933b), 40.
[50] Te Rangi Hiroa (1927), 73.
[51] Christian, 85.
[52] Brown (1931), 124.
[53] Metraux, 195, fig. 15d. (The Bishop Museum catalogue number of this specimen is B3567).
[54] Henry, 63.
[55] Ibid., 609.
[56] Te Rangi Hiroa (1930), 105.
[57] Collocott, 19.
[58] Best (1925b), 130,132.
[59] Bishop (1940), 9; Malo, 161.
[60] Fornander and Thrum, III, 170.
[61] Bishop Handbook, 31.
[62] Bryan (1938), 23.
[63] Bishop (1940), 14, 84.
[64] Lawarence, 44-46.
[65] Stubbs, 34.
[66] Malo, 110.
[67] Beckwith (1932), 150; native text, 151.
[68] Malo, 84.
[69] Ibid., 91, 95.
[70] The catalogue numbers with significant dates and information are as follows: Harvard specimens D-2930; 37,647, Island of Oahu, 1884; 37,666, Island of Oahu, 1884; 37,667, Island of Oahu, 1884; 50,763, American Antiquarian Society, 1890. Salem specimens E19,629,629; E16,846; E21,327. Mrs. Bishop's specimens: 46,71,73. See Bishop, 1940, pp. 83-84.
[71] See basketry on gourds, p. 68.
[72] These are described in the section on trunks; see p. 29.
[73] Dalton, Pl. XVL, 7; 244.
[74] Phillips, no p. number.
[75] Handy (1923), 66; Linton, 293, 355.
[76] Linton, 357.
[77] Ibid.
[78] Ibid., 358.
[79] Melville, 132.
[80] Metraux, 157.
[81] Henry, 245.
[82] Ibid., 621.
[83] Ibid., 625.
[84] Aitken, 38.
[85] Ibid.
[86] Brigham (1908), 140.
[87] Malo, 110.

[88]Aitken, 38.
[89]Te Rangi Hiroa (1927), 73.
[90]Andersen (n.d.), 77.
[91]Te Rangi Hiroa (1927), 73.
[92]Op. cit., 77.
[93]Best (1925b), 131.
[94]Aitken, 40.
[95]Bishop Handbook, 31; Also Lawrence, 44-46.
[96]Craft, opp. 101.
[97]Lawrence, 76.
[98]Bryan (1938), 23.
[99]Metraux, (1940) 156.
[100]Bishop Handbook, 31.
[101]Brigham (1908), 141. This author says the gourds used were "Curcubita" (sic).
[102]Brigham (1908), 140-141; Bishop Handbook, 31.
[103]Fornander and Thrum, I, 278.
[104]Routledge, 218; Metraux, 225.
[105]Stokes (1906), 148-149; for similar statements see Bryan (1938), 23 and Lawrence, 76.
[106]Bishop Handbook, 70.
[107]Emerson MSS. in the Peabody Museum of Salem.
[108]Malo, 277.
[109]Metraux, 236-237.
[110]Ibid., 237.
[111]Thomson, 535.
[112]Routledge, 265.
[113]McAllister (1932b), Pl. 5,b; 37-40.
[114]Bishop (1940), 11.
[115]Brigham (1908), 140.
[116]Fornander and Thrum, III, 170.

CHAPTER IV

[1]Roberts, 55.
[2]Bryan (1938), 55.
[3]Op. cit.
[4]Bishop (1940), 105.
[5]Emerson (1909), 144.
[6]Barrot, 33-34; Roberts, 55.
[7]Cook and King (1785), Plate 62.
[8]Emerson (1909), 107-144; Roberts, 55-56, 366. Bishop (1940), 59.
[9]Bishop Handbook, fig. 40.
[10]Emerson (1909), 107.
[11]For the uliuli see Roberts, 237-260; for words and description of uliuli hula see Emerson (1909), 108-112.
[12]Emerson (1909), 107.
[13]Peabody Museum Salem E43820 and 43821. See Bishop, 1940, 105. 68 is decorated and is the same specimen as figured by Emerson (1909), Plate XI.
[14]Emerson (1909), 107.
[15]Roberts, 55-56, 366.
[16]Catalogue number E19, 773. For an account of the

history of the Thurston collection see Dodge, 156.

[17] Roberts, 55.

[18] For general discriptions see Ibid. 55-56; Bishop (1940), 59-60.

[19] Roberts, 366.

[20] Alexander, 92 gives the native name for this instrument as *hokeo* but I can find no other authority for this. Fornander and Thrum III, 168 gives *hokeo* as the name of a long gourd for carrying one's kit (sic.).

[21] The two most complete descriptions are found in Emerson (1909), 142-143 and Roberts, 51-53. Other references are Bryan (1938), 23, 55; Winne, 204; Blackman, 20.

[22] Bryan (1915), 82.

[23] Roberts, 51.

[24] Roberts, 51.

[25] Bishop Handbook, 46; Roberts, 51-52; See Chapter VI, Decoration.

[26] Roberts, 52; Emerson (1909), 142; Bishop (1940), 57-58; Also Bryan (1915), 82.

[27] Roberts, 52. For examples of the rhythm of the *ipu hula* see musical notation in ibid, 215 ff.

[28] Emerson (1909, 142.

[29] Roberts 360-362. Stubbs, 34, says "These gourds served as receiving vessels in the household, while the longer ones, covered with shark skins, were used as drums." This peculiar reference is the only one I have found to a headed drum made of a gourd in the Hawaiian Islands. I think the author must have confused the *hula* drums with the large wooden drums headed with shark skin.

[30] Routledge, 240.

[31] Metraux, 35.

[32] Metraux, 356.

[33] This is the name used by Roberts, 44; Bishop (1940), 55; Bryan (1938), 55 and other modern authorities. Alexander, 91; Bryan (1915), 83; and Dalton (1897), 230 all give the name incompletely as *kio* or *kio kio*. Morris, 48 gives *Hano* or *Kio Kio*. Emerson (1909), 146 gives the natives name as *pu-a*, but Roberts, op. cit., says specifically that she never heard this term during her field work. Roberts, op. cit., cites J. S. Emerson in his manuscript catalogue as cal-

ling the instrument *ipu hoehoe*, a name which she says was also applied to the bamboo nose flutes, although in her descriptions of these instruments (35-38) she does not give the term.
³⁴Bishop Handbook, 51.
³⁵Bryan (1915), 83.
³⁶Emerson (1909), 146.
³⁷Roberts, 44.
³⁸Ibid., 44.
³⁹Roberts, 348-349.
⁴⁰Speck (1941), 44-46
⁴¹J. S. Emerson was a noted collector and dealer in Hawaiian ethnological material who lived in the Islands.
⁴²Edge-Partington, 35, no. 1; Andersen (1934).
⁴³Op. cit., 19, nos. 4, 5; Best (1925a), 159, follows Edge-Partington and accepts the Tahiti origin.
⁴⁴Op. cit., 295, A & B.
⁴⁵Hamilton, 391
⁴⁶Edge-Partington, 386, No. 7; Andersen (1934), 295.
⁴⁷Best (1924b), v. II, 160; Hamilton, 391.
⁴⁸Hamilton, 391; Best (1924b), II, 160; Andersen (1934), 294-296.
⁴⁹Op. cit., Tregear (1904), 65.
⁵⁰Op. cit., 294.

⁵¹Ibid., 296
⁵²*Koauau* is the name applied to the short, straight flutes made of bone or wood and played with the mouth.
⁵³Best (1925a), 147.
⁵⁴Best (1925), 158-160.
⁵⁴ᵃ Dodge and Brewster.
⁵⁵Hamilton, 39.
⁵⁶Andersen (1934), 294-296.
⁵⁷Best, (1924b), II, 160.
⁵⁸Best (1925a), 158.
⁵⁹Roberts, 44, 359, pl. III, A.
⁶⁰Edge-Partington, 60.
⁶¹Bishop Handbook, 51.
⁶²Edge Partington, 35, No. 1; Andersen (1934), 296; Best, 1925, 159.
⁶³Roberts, 359; Best (1925a), 159.

CHAPTER V

¹A good example of this use is the article by G. K. Spence, "The Sacred Calabash", *Touring Topics*, vol. 25, No. 5 (Beverly Hills, Cal., April, 1933), 14-15, 38.
²For some of the controversy about this see Rodman (1927), 867-872; Rodman (1928), 75-85; Stokes (1928), 85-87; Hiroa (1926), 193-194.

[3] Best (1925a), 89.
[4] Ibid., 88.
[5] Best (1925a), 89.
[6] Ibid., 92.
[7] Ibid.
[8] Catalogue number 37,650 (Harvard).
[9] Personal correspondence with Te Rangi Hiroa.
[10] Hamilton, 430.
[11] Catalogue number E19,621 (Salem).
[12] Brigham (1908), 146.
[13] Malo, 284-286.
[14] Fornander and Thrum, III, 192, 194.
[15] Emory (1933), 1952; Bishop (1940), 50-51.
[16] Fornander and Thrum, 192.
[17] Catalogue number E19,627.
[18] Edge-Partington, 60, n. 14.
[19] Edge-Partington, 35, no. 1.
[20] Metraux, 149.
[21] Metraux, 353.
[22] Speck (1941a), 40.
[23] Malo, 306.
[24] Best (1925b), 130.
[25] Handy (1940), 211.
[26] Fornander and Thrum, 186.
[27] Bishop Handbook, 70; Brigham (1908), 146.
[28] McAllister (1933b), 40.
[29] Thomson, 535.
[30] Handy, Pukui and Livermore, 15-16; Bishop Handbook, 61, 63; Brigham (1908), 146.
[31] Bishop Handbook, 63.
[32] Brigham (1908), 142-143; Bryan (1938), 23.
[33] Bishop Handbook, 28, 33.
[34] Brigham (1908), 143.
[35] Speck (1941a), 31.
[36] Brigham (1908), 144.
[37] Lawrence, 44-46.
[38] Speck (1941b), 676-678.
[39] Best (1925b), 132.
[40] Cook and King (1785), album, plates, 65 and 66.
[41] Edge-Partington, 54, No. 4.
[42] Bishop (1940), 39.
[43] Bryan (1938), 44.
[44] Jarvis, 74-75.
[45] I am indebted for this reference to Mr. Roger Duff of the Canterbury Museum, Christchurch, N.Z. as no copy of this book was available to me.
[46] Tregear (1904) 266.
[47] Robley, 58.
[48] Ibid., 60.
[49] Andersen (n.d.) 352.
[50] Brigham (1908), 146.
[51] Linton, 294
[52] Fornander and Thrum, 168.
[53] Thomson, 535.

54 Metraux, 393.
55 Thomson, I, 75.

CHAPTER VI

[1] I am greatly indebted to Kenneth P. Emory of the Bishop Museum for information about Hawaiian methods.
[2] Ellis (1827), 377.
[3] Brigham (1908), 145; Bishop Handbook 31.
[4] Bennett, 84-85.
[5] Bryan (1915), 209.
[6] Emory, personal correspondence, Nov. 6, 1941.
[7] Ibid. Nov. 6, 25, 1941.
[8] Fornander and Thrum, III, 168.
[9] Emory, personal correspondence, Nov. 6, 1941.
[10] Greiner, 47.
[11] Emory, personal correspondence, Oct. 8, 1941.
[12] Greiner, 47.
[13] Greiner, 47-9.
[14] Ibid., 49, Pl. XXI Phillipps.
[16] Ibid.
[17] Stokes (1906).
[18] Linton, 357-358.
[19] Brief accounts and illustrations of Hawaiian basketry on gourds can be found in Brigham (1906), 63 ff., Bishop Handbook, 65, and Bishop (1940), 14-15.
[20] Brigham (1906), 64.
[21] Bishop Handbook, 63.

CHAPTER VII

[1] Henry, 345.
[2] Handy, 398.
[3] Ibid., 448
[4] Handy (1927), 173.
[5] Ibid., 184.
[6] Ibid., 235.
[7] For an account of all the details of this ceremony see Malo, 135-139.
[8] Handy (1927), 165.
[9] Handy (1927), 226-227.
[10] Alexander, 72-73; Handy (1927), 237.
[11] Beckwith (1932), 120; native text 121.
[12] Handy (1927), 68.
[13] Beckwith (1932), 38; native text 39.
[14] Henry, 197.
[15] Beckwith (1932), 142, native test, 143.
[16] Andrews, 392.
[17] Henry, 620.
[18] Andersen (n.d.), 12.
[19] Ibid., 294.
[20] For various versions see Fornander and Thrum, III, 72; Rice, 73; Thrum, 63; Westervelt (1910), 114-118;

Westervelt (1915), 59-60; Dixon 55; Beckwith (1940), 86-87; Andersen (1928), 54.
[21] Fornander and Thrum, I, 310-318.
[22] Ibid., 310, 318.
[23] Ibid., 316, 318.
[24] Beckwith (1940), 194-198.
[25] Henry, 526.
[26] Henry, 528.
[27] Henry, 581.
[28] Beckwith (1940), 99.
[29] Metraux, 321.
[30] Fornander and Thrum, II, 50; Rice, 63.
[31] Fornander and Thrum, III, 351-352.
[32] Metraux, 368-369.
[33] Ibid., 376.
[34] Thomson, 532.
[35] Metraux, 378.
[36] Handy (1930), 109.
[37] Best (1925c), I, 782-783.
[38] Collocott, 19.
[39] Dickey, 35-36, 39.
[40] Fornander and Thrum, III, 212.
[41] Dickey, 41.
[42] Dickey, 142-143; Handy (1925), 6, 7, 30, 71.
[43] Judd. All of the following proverbs and riddles come from this work and can be found there in the native text. Following is a complete list of the numbers of the proverbs and riddles mentioning gourds or related terms. Proverbs and sayings 157, 169, 226, 254, 276, 289, 384, 556, 615, 663, 741, 756; Riddles 30, 40, 67, 115, 134, 149, 180, 225, 226, 227.

CHAPTER VIII

[1] Hiroa (1938), 75.
[2] Hornell, 64-65.
[3] Lisiansky, 72, 126.
[4] Henry, 63.
[5] Aitken, 14.
[6] Te Rangi Hiroa (1927), 48
[7] Metraux, 157.
[8] See for example Alexander, 83; Malo, 44; Jarvis, 74-5.
[9] Anonymous, 151.
[10] Brigham (1908), 137.
[11] McAllister (1933b), 38.
[12] Emory (1928), 35.
[13] Ibid. 47.
[14] Ibid., 114.
[15] Dixon (1789), 53.

APPENDIX

It is commonly known that the more important a plant or animal becomes in the culture of a specific people the more names and words there are associated with it. The following list then, is meant to indicate the importance of the gourd in the culture of the Polynesians and is not intended as a comprehensive list of all the Polynesian gourd words. No exhaustive list has been made and the list consists simply of those words found in the works of various authors consulted during the writing of this book.

For the uninitiated who may want to pronounce native words it can be said that the consonants are pronounced like those in English. The pronunciation of the vowels is, for the most part constant, and is approximately as follows: a as in "father", e as "a" in "may", i as "e" in "we", o as in "old", and u as "oo" in "moo".

AUSTRAL

miti hue	gourd filled with raw fish in sauce	Aitken, 1930, 40

COOK

hue kava	gourd (Aitutaki)	Te Rangi Hiroa 1927, 48.
taha	water container	Te Rangi Hiroa 1927, 48.
'ue	gourd (Rarotonga)	Brown, 1935, 319.

EASTER

hue	gourd	Métraux, 1940, 157.
hipu	container	Métraux, 1940, 157.

kaha	gourd for mulberry bark or potatoes	Métraux, 1940, 157.
ki roto ki te ipu	gourd for body paint	Métraux, 1940, 237.
pakahara	shell, particularly of gourd	Métraux, 1940, 157.

HAWAII

anoano	gourd seed	Handy, 1940, 207.
hahano ipu	syringe	Handy, Pukui Livermore, 1934, 16.
heu	pubescence	Handy, 1940, 207.
hinai poepoe	gourd covered with basketry	Brigham, 1906, 64ff.
hokeo	long gourd for carrying one's kit	Fornander & Thrum, III, 168.
holei	colored gourd	Handy, 1940, 208.
hua ipu	gourd	Handy, 1940, 207.
huewai	gourd water bottle	Bishop Handbook, 32.
huewai pawehe	decorated water bottle	Brigham, 1908, 144.
huewai puali	hourglass-shaped bottle gourd	Handy, 1940, 208
huewai pueo	hourglass-shaped water bottle	Bishop Handbook, 32.
huli lau	large container for clothing.	Handy, 1940, 208.

Appendix

hulilau	broad variety of *ipu nui*	Handy, 1940, 207.
hulilau	name of bitter gourd	Fornander & Thrum, III, 170.
hulilau	small household gourds suspended by a string instead of a net	Fornander & Thrum, III, 168.
iole holo kule	small nut sized gourd	Handy, 1940, 208.
io	round light colored gourd about 1 foot in diameter	Handy, 1940, 208.
ipu	gourd	Brigham, 1908, 137.
ipu aho	for fish hooks and lines	Stokes, 1906, 148.
ipu ai	food container	Handy, 1940, 208.
ipu awaawa	bitter gourd	Handy, 1940, 207.
ipu hokeo	gourd clothes trunk	Bryan, 1938, 23.
ipu hokiokio	gourd whistle	Roberts, 1926, 44.
ipu holoholona	for fish hooks and lines	Stokes, 1906, 148.
ipu hula	gourd drum	Bryan, 1938, 23.
ipu i'a or *ipu kai*	for serving fish	Handy, 1940, 208.
ipu ka eo	full food bowl	Malo, 1903, 91, 95.
ipu kai	small gourd for meat or fish	Handy, 1940, 208.
ipu kukui	stone lamp	Brigham, 1908, 137.

ipu le'i	for fish hooks and lines	Stokes, 1906, 148.
ipu lei	for holding flower necklaces	Handy, 1940, 208.
ipu manalo	sweet gourd	Handy, 1940, 207.
ipu nui	giant gourd	Brigham, 1908, 137.
ipu pawehe	gourd vessel with surface decoration	Bishop, 1940, 14.
ipu pohue	undecorated gourd	
ipu wai	gourd water bottle	Bryan, 1938, 23.
iwi	gourd shell	Handy, 1940, 207.
ka	gourd vine	Handy, 1940, 207.
kaku	name of the bitter gourd	Fornander & Thrum, III, 170.
kamanomano	name of the bitter gourd	Fornander & Thrum, III, 170.
kilu	gourd object tossed in a game	Bishop, 1940, 50.
kohu or *kilu*	container for fish	Handy, 1940, 208.
kukae iwa	green skinned gourd with white patches	Handy, 1940, 207.
laha	gourd with painted patterns	Handy, 1940, 208.
lono lau	deep variety of ipu nui	Handy, 1940, 207.
mua	round narrow gourd	Handy, 1940, 208.
nounou	a tiny gourd	Handy, 1940, 208.

Appendix

olo	syringe	Fornander & Thrum, III, 168.
olo	long gourd	Handy, 1940, 207.
omo	name of the bitter gourd	Fornander & Thrum, III, 170.
olowai	gourd water bottle for canoe	Stokes, 1906, 114.
pahu aho	for fish hooks and lines	Stokes, 1906, 148.
paka	name of the bitter gourd	Fornander & Thrum, III, 170.
paka or *pakaka*	a shallow dish	Handy, 1940, 208.
pakaka	small quantity gourd	Handy, 1940, 208.
palaai	pumpkin shaped gourd	Handy, 1940, 207.
piko	name of the bitter gourd	Fornander & Thrum, III, 170.
piko	apex of the gourd	Handy, 1940, 207.
pu li' uli u'	small coconut sized gourd	Handy, 1940, 208.
pohue	gourd for fish bait	Fornander & Thrum, III, 186.
pohue	broken piece of gourd	Tregear, 1891, 91.
ulili	spinning rattle	Roberts, 1926, 55.
uliuli	gourd rattle	Roberts, 1926, 54.
umeke	gourd vessel	Stokes, 1906, 150.
umeke ka eo	full food bowl	Malo, 1903, 91, 95.

uneke papa ole	empty bowl i.e. unripe gourd	Malo, 1903, 91, 95.
umeke pawehe	gourd vessel with surface decoration	Bishop Handbook, 33.
umiumi	gourd tendrils	Handy, 1940, 207.

MANGAREVA

hue	gourd	Tregear, 1891, 91.
ipu	gourd	Tregear, 1891, 107.
uhe	gourd still on vine	Tregear, 1891, 91.

MARQUESAS

hue	gourd in all islands except Nuku Hiva island	Brown, 1935, 319.
hue	container with large opening	Nuttall, correspondence.
hue epo	called a urinal by the missionaries	Nuttall, correspondence.
hue henua	the earth: missionaries brought in a globe for teaching and it received this name	Nuttall, correspondence.
hue kai	an edible pumpkin	Nuttall, correspondence.
hue kauiu	melon	Nuttall, correspondence.
hue ma'oi	gourd in Nuku Hiva	Brown, 1935, 319.
hue mao'i	an indigenous plant	Nuttall, correspondence.

Appendix

hue vai	gourd water bottle	Nuttall, correspondence.
ipu	container with small opening	Nuttall, correspondence.
ipu a'ehi	coconut shell container	Nuttall, correspondence.
ipu hue	drinking cup	Brown, 1935, 319.
ipu'o'o	human skull container	Nuttall, correspondence.
putui hue	water or oil container	Brown, 1935, 319.

NEW ZEALAND

hika	a stage of growth	Best, 1925b, 132.
hue	gourd	Brown, 1935, 319.
hue kaupeka	gourd which decreases in size at the stem end	Best, 1925b, 133.
hue kautu	gourd with a curved stem end used as a water vessel	Best, 1925b, 131.
hue kautu	gourd that grows in an upright position	Best, 1925b, 133.
hue mori	gourd after being taken from the vine	Best, 1925b, 131.
ipu	food or water vessel	Best, 1925b, 132.
ipu whakairo	gourd food bowl for chief	Phillipps, 1938.
kahaka	food or water vessel	Best, 1925b, 132.
karaha	bowl	Best, 1925b, 132.

kareha	wide mouth gourd bowl	Andersen, 1942, 375.
kawai	young runners of gourd vine	Best, 1925b, 132.
kawekawe	runner of gourd vine	Best, 1925b, 133.
kiaka	food or water vessel	Best, 1925b, 132.
kiato	for *taha wai* (water vessels)	Best, 1925b, 131.
kimi	food or water vessel	Best, 1925b, 132.
kina	gourd of flattened form	Best, 1925b, 131.
koaka	food or water vessel	Best, 1925b, 132.
kokako-ware	variety of size or shape. Bay of Plenty district.	Best, 1925b, 131.
koki	small form introduced by Europeans	Best, 1925b, 131.
kotawa	young gourds fit to eat	Best, 1925b, 132.
kowenewene	gourd. East Coast of North Island	Best, 1925b, 129.
mahanga	dumbbell-shaped vessels for preserving birds	Best, 1925b, 131.
manuka-roa	for making bowls. Bay of Plenty district	Best, 1925b, 131.
oko	gourd bowl	Best, 1925b, 131.
pahaka	food or water vessel	Best, 1925b, 132.
pahawa or *pahaua*	variety of size or shape	Best, 1925b, 131.
papapa	food or water vessel	Best, 1925b, 132.

Appendix

pare-tarakihi	large form	Best, 1925b, 131.
patangaroa	third leaf to appear	Best, 1925b, 132.
potaka hue	hummingtop	Best, 1925a, 89.
puau	thick rind variety	Best, 1925b, 131.
pukahu	spongy interior of the gourd	Best, 1925b, 131.
putaihinu	fourth leaf to appear	Best, 1925b, 132.
rau kakano	first leaves of the gourd seedling	Best, 1925b, 132.
rautara	third leaf to appear	Best, 1925b, 132.
ripa	gourd bowl	Best, 1942, 327.
rorerore	variety of size or shape	Best, 1925b, 131.
taha	food or water vessel	Best, 1925b, 132.
taha huahua	large gourd vessel for potted food	Best, 1925b, 131.
tahe	food or water vessel	Best, 1925b, 132.
tatara	for *taha huahua* (food)	Best, 1925b, 131.
taha wai	water vessel	Best, 1925b, 131.
tawha	food or water vessel	Best, 1925b, 132.
upoko-taupo	variety of size or shape. Bay of Plenty district.	Best, 1925b, 131.
wai	food or water vessel	Best, 1925b, 132.
wenewene	gourd. East coast of North Island	Best, 1925b, 129.
whakahau-matua	for making large vessels, *taha huahua*	Best, 1925b, 131.

whangai-rangatira	variety of size or shape	Best, 1925b, 131.
whareiuu	variety of size or shape. Bay of Plenty district.	Best, 1925b, 131.

SAMOA

fangu	gourd oil container	Te Rangi Hiroa, 1930, 105.
fue	gourd	Best, 1925, 129.

SOCIETY

aroro	container for hair oil	Brown, 1935, 319.
hue	gourd	Brown, 1935, 319.
hueaere	a gourd vine all leaves but with no fruit	Tregear, 1891, 90.
hue fafaru	gourd for raw fish	Henry, 1928, 245.
huehue	a small gourd	Tregear, 1891, 90.

TONGA

fangu	gourd oil container	Collocott, 1928, 19.

TUAMOTU

hue	gourd	Brown, 1935, 319.

BIBLIOGRAPHY

Aiken, Robert T., "Ethnology of Tubuai", *Bernice P. Bishop Museum* Bulletin 70 (Honolulu, 1930).

Alexander, W. D., *A Brief History of the Hawaiian People* (New York, 1891).

Andersen, Johannes C., *Maori Life in Ao-tea* (Wellington, n.d.).

Andersen, Johannes C., *Myths and Legends of the Polynesians* (London, 1928).

Andersen, Johannes, C., "Maori Music with its Polynesian Background," *Memoir No. 10 of the Polynesian Society* (Plymouth, N. Z., 1934).

Andersen, Johannes C., "Maori Place Names", *Memoir No. 20 of the Polynesian Society* (Wellington, N. Z., 1942).

Andrews, Lorrin, *A Dictionary of the Hawaiian Language* (Honolulu, 1865).

Anonymous, "Hawaiian Calabashes", *The Hawaiian Annual 1902* (Honolulu, 1901).

Barrot, Adolphe, "Visit of the French sloop of war Bonite, to the Sandwich Islands, in 1836", translated for *The Friend*, 8, 5 (Honolulu, May 1, 1850).

Beaglehole, Ernest and Pearl, "Ethnology of Pukapuka", *Bernice P. Bishop Museum Bulletin* 150 (Honolulu, 1938).

Beaglehole, Ernest, "The Polynesian Maori", *The Journal of the Polynesian Society*, 49, 1 (New Plymouth, N. Z., 1940).

Beasley, H. G. "New Zealnad Wooden Bowls", *Ethnologia Cranmorensis*, 3, (Cranmore Ethnographical Museum, 1938).

Beckwith, Martha Warren, ed., "Kepelino's Traditions of Hawaii", *Bernice P. Bishop Museum Bulletin* 95 (Honolulu, 1932).

Beckwith, Martha, *Hawaiian Mythology*, (New Haven, 1940).

Bennett, Wendell Clark, "Archaelogy of Kauai", *Bernice P. Bishop Museum Bulletin* 80 (Honolulu, 1931).

Best, Elsdon, "Polynesian Voyagers", *Dominion Museum Monograph* 5 (Wellington, 1923).

Best, Elsdon, "Maori Religion and Mythology", *Dominion Museum Bulletin* 10 (Wellington, 1924a).

Best, Elsdon, *The Maori*, I - II, (Wellington, 1924b).

Best, Elsdon, "Games and Pastimes of the Maori", *Dominion Museum Bulletin* 8 (Wellington, 1925a).

Best, Elsdon, "Maori Agriculture", *Dominion Museum Bulletin* no. 9 (Wellington, 1925b).

Best, Elsdon, *"Tuhoe, The Children of the Mist"*, I - II (New Plymouth, N. Z., 1925c).

Best, Elsdon, "Maori Agriculture: Cultivated Food Plants of the Maori and Native Methods of Agriculture", *The Journal of the Polynesian Society*, Vol. 40, No. 1, (New Plymouth, N. Z. March 1931).

Best, Elsdon, "Forest Lore of the Maori", *Memoir No. 19 of the Polynesian Society* (Wellington, N. Z., 1942).

Bishop, Edward Sereno, *Reminiscences of Old Hawaii (Honolulu,* 1916).

Bishop, Marcia Brown, *Hawaiian Life of the Pre-European Period* (Peabody Museum of Salem, 1940).

Bishop Museum Handbook, Part I, *The Hawaiian Collections* (Honolulu, 1915).

Blackman, William Fremont, *The Making of Hawaii* (New York, 1906).

Brigham, William T., "Mat and Basket Weaving of the Ancient Hawaiians", *Bernice P. Bishop Museum Memoirs*, II, I (Honolulu, 1906).

Brigham, William T., "The Ancient Hawaiian House", *Bernice P. Bishop Memoirs*, II, 3 (Honolulu, 1908).

Brown, Forest B. H., "Flora of Southeastern Polynesia", *Bernice P. Bishop Bulletin* 84 (Honolulu, 1931).

Brown, Forest B. H., "Flora of Southeastern Polynesia, III, Dicotyledons", *Bernice P. Bishop Museum Bulletin* 130, (Honolulu, 1935).

Bryan, E. H., Jr., *Ancient Hawaiian Life* (Honolulu, 1938).

Bryan William Alanson, *Natural History of Hawaii* (Honolulu, 1915).

Burrows, Edwin, G., "Ethnology of Futuna", *Bernice P. Bishop Museum Bulletin* 138 (Honolulu, 1936).

Burrows, Edwin G., "Ethnology of Uvea (Wallis Island)", *Bernice P. Bishop Museum Bulletin* 145 (Honolulu, 1937).

Burrows, Edwin G., "Western Polynesia, A Study in Cultural Differentiation" *Ethnological Studies*, vol, 7 (Gothenburg Ethnographical museum, 1938).

Christian, F. W., *Eastern Pacific Lands: Tahiti and the Marquesas Islands* (London, 1910).

Collocott, E. E. V., "Tales and Poems of Tonga", *Bernice P. Bishop Museum Bulletin* 46 (Honolulu, 1928).

Cook, James, *A Voyage Towards the South Pole, and Round the World*, I - II (London, 1777).

Cook, Captain James and King, Captain James, *A Voyage to the Pacific Ocean. Undertaken by the Command of His Majesty, for Making Discoveries in the Northern Hemisphere. Performed under the Direction of Captains Cook, Clerke, and Gore, In His Majesty's Ships the Resolution and Discovery: in the Years 1776, 1777, 1778, 1779, and 1780*, I - III, album (London, 1785).

Cooke, George H., "Te Pito te Henua, Known as Rapa Nui: Commonly Called Easter Island, South Pacific Ocean. Latitude 27° 10' S., Longitude 109° 26' W.", *Report of the U. S. National Museum, Under the Direction of the Smithsonian Institution, for the Year Ending June 30, 1897* (Washington, 1899).

Craft, Mabel Clare, *Hawaii Nei* (San Francisco, 1899).

Dalton, O. M., "Notes on an Ethnographical Collection From the West Coast of North America (More Especially California, Hawaii, and Tahiti, Formed During the Voyage of Captain Vancouver 1790-1795, and now in the British Museum", *Internationales Archiv fur Ethnographie* (Leiden, 1897).

Dickey, Lyle A., "String Figures From Hawaii", *Bernice P. Bishop Museum Bulletin* 54 (Honolulu, 1928).

Dixon, Capt. George, *A Voyage Round the World* (London 1789).

Dixon, Roland B., *The Mythology of all Races: Oceanic* (Boston, 1916).

Dixon, Roland B., "The Problem of the Sweet Potato in Polynesia", *American Anthropologist*, vol. 34 (Menasha, Wisc, 1932).

Dixon, Roland B., "The Long Voyages of the Polynesians", *Proceedings of the American Philosophical Society*, Vol. 74 (Philadelphia, 1934).

Dodge, Ernest S., "Four Hawaiian Implements in the Peabody

Museum of Salem", *Journal of the Polynesian Society*, 48, 3, (Wellington, 1939).

Dodge, Ernest S. and Edwin T. Brewster, "The Acoustics of Three Maori Flutes", *Journal of the Polynesian Society*, Vol, 54, pp. 39-61, (1945).

Eames, Arthur J. and Harold St. John, "The Botanical Identity of the Hawaiian Ipu Nue or Large Gourd", *American Journal of Botany*, Vol. 30, No. 3, pp. 255-259, March, 1943.

Ellis, William, *Narrative of a Tour Through Hawaii or Owhyhee* (London, 1827) 3rd ed., pp. 375-377.

Ellis, William, *Polynesian Researches* I - IV (London, 1831)

Emerson, J. S., *Manuscript Catalogue of Objects sold to the Peabody Musuem of Salem in the Peabody Museum* (1906).

Emerson, Nathaniel, "Underwritten Literature of Hawaii", *Bureau of American Ethnology Bulletin*, 38, (Washington, 1909).

Edge-Partington, James, *An Album of the Weapons, Tools, Ornaments, Articles of Dress etc. of the Natives of the Pacific Islands*, I - III (Manchester, 1890, 1895, 1898).

Emory, Kenneth P., "The Island of Lanai, a Survey of Native Culture", *Bernice P. Bishop Museum Bulletin* 12, (Honolulu, 1924).

Emory, Kenneth P., "Archaelogy of Nihoa and Necker Islands", *Bernice P. Bishop Museum Bulletin* 53 (Honolulu, 1928).

Emory, Kenneth P., "Sports, Games, and Amusement", Chapter 14, *Ancient Hawaiian Civilization* (Honolulu, 1933).

Emory, Kenneth P., "Manahiki: Inlaid Wooden Bowls", *Ethnologia Cranmorensis*, 4 (Cranmore Ethnographical Museum, 1939).

Fornander, Abraham and Thomas G. Thrum, "Hawaiian Antiquities and Folk-Lore", I - III, *Bernice P. Bishop Museum Memoirs*, VI (Honolulu I, 1916-17; II, 1918-19; III, 1919-20).

Gifford, Edward Winslow, "Tongan Myths and Tales", *Bernice P. Bishop Museum Bulletin* 8 (Honolulu, 1924).

Gonzalez, Felipe, *The Voyage of Captain Don – to Easter Island in 1770-1* (Cambridge: The Hakluyt Society, 1980).

Greiner, Ruth H., "Polynesian Decorative Designs", *Bernice P. Bishop Bulletin* 7 (Honolulu, 1923).

Hamilton, Augustus, *Maori Art* (Wellington, 1901)

Handy, E. S. Craighill, "The Native Culture in the Marquesas", *Bernice P. Bishop Museum Bulletin* 9 (Honolulu, 1923).

Handy, E. S. Craighill, "Polynesian Religion", *Bernice P. Bishop Museum Bulletin* 34 (Honolulu, 1927).

Handy, E. S. Craighill, "Marquesan Legends", *Bernice P. Bishop Museum Bulletin* 69 (Honolulu, 1930).

Handy, E. S. Craighill, Mary Kawena Pukui, Katherine Livermore, "Outline of Hawaiian Physical Therapeutics", *Bernice P. Bishop Museum Bulletin* 126 (Honolulu, 1934).

Handy, E. S. Craighill, "The Hawaiian Planter: Volume I: His Plants, Methods and Areas of Cultivation." *Bernice P. Bishop Museum Bulletin* 161 (Honolulu, 1940).

Handy, Willowdean C., *L'Art des Iles Marquises* (Paris, 1938).

Henry, Teuira, "Ancient Tahiti", *Bernice P. Bishop Museum Bulletin* 48 (Honolulu, 1928).

Heyerdahl, Thor, *American Indians in the Pacific*, London, 1952.

Bibliography

Hillerbrand, W. F., *Flora of the Hawaiian Islands*, (Heidelberg, 1880).

Hornell, James, "String Figures From Fiji and Western Polynesia", *Bernice P. Bishop Museum* (Honolulu, 1927).

Hornell, James, *Canoes of Oceania*, Vol. I. *The Canoes of Polynesia, Fiji, and Micronesia* (Honolulu, 1936).

Howells, William *The Pacific Islanders*, New York, 1973.

Jarvis, James J., *History of the Hawaiian or Sandwich Islands* (Boston, 1843).

Johnson, Rubellite Kawena and John Kaipo Mahelona, *Na Moa Hoka*. Topgallant Publishing Co., Ltd., Honolulu, 1975.

Judd, Henry P., "Hawaiian Proverbs and Riddles", *Bernice P. Bishop Museum Bulletin* 77 (Honolulu, 1930).

La Perouse, *The Voyage of – Round the World, in the Years 1785, 1786, 1787, and 1788*. I - II (London, 1798).

Lawrence, Mary S., *Old Time Hawaiians and Their Work* (Boston 1912).

Lewis, David, *We the Navigators*, Australian National University Press, Canberra, 1972.

Linton, Ralph, "The Material Culture of the Marquesas Islands", *Memoirs of the Bernice P. Bishop Museum*, Vol. VIII, No. 5 (Honolulu, 1923).

Loeb, Edwin M., "History and Traditions of Niue", *Bernice P. Bishop Museum Bulletin* 32 (Honolulu, 1926).

Macgregor, Gordon, "Ethnology of Tokelau Islands", *Bernice P. Bishop Museum Bulletin* 146 (Honolulu, 1937).

Malo, David, *Hawaiian Antiquities* (Honolulu, 1903).

McAllister, J. Gilbert, "Archaeology of Oahu", *Bernice P. Bishop Museum Bulletin* 104 (Honolulu, 1933a).

McAllister, J. Gilbert, "Archaelogy of Kahoolawe", *Bernice P. Bishop Museum Bulletin* 115 (Honolulu 1933b).

Melville, Herman, Typee: *A Peep at Polynesian Life, During A Four Months Residence in a Valley of the Marquesas* (New York, 1855).

Merrill, Elmer Drew, *The Botany of Cook's Voyages*, Chronica Botanica Co., Waltham, Mass., 1954.

Metraux, Alfred, "Ethnology of Easter Island", *Bernice P. Bishop Museum Bulletin* 160 (Honolulu, 1940).

Morris, Frances, "Catalogue of the Musical Instruments of Oceanica and America", *Calalogue of the Crosby Brown Collection of Musical Instruments*, Vol. II (The Metropolitan Museum of Art, New York, 1914).

Pukui, Mary Kawena and Samuel H. Elbert, *English-Hawaiian Dictionary*, University of Hawaii Press, 1964.

Pukui, Mary Kawena and Samuel H. Elbert, *Hawaiian-English Dictionary*, University of Hawaii Press, 1957.

Rice, William Hyde, "Hawaiian Legends", *Bernice P. Bishop Museum Bulletin* 3 (Honolulu, 1923).

Roberts, Helen H., "Ancient Hawaiian Music", *Bernice P. Bishop Museum Bulletin* 29 (Honolulu, 1926).

Robley, Major-General, *Moko;* or *Maori Tattooing* (London, 1896).

Rodman, Rear Admiral Hugh, "The Sacred Calabash", *United States Naval Institute Proceedings*, Vol. III, No. 8 (Menasha, Wisc. 1927).

Rodman, Reprint of the above article, *"The Journal of the*

Polynesian Society," Vol. 37, No. 1, (New Plymouth, N. Z., March 1928).

Speck, Frank G., *Gourds of the Southeastern Indians* (Boston, 1941a).

Speck, Frank G., "The Gourd Lamp Among the Virginia Indians." *American Anthropologists*, Vol. 43, No. 4, (Menasha, Wisc. 1941b).

Stokes, John F. G., "Hawaiian Nets and Netting", *Bernice P. Bishop Museum Memoirs*, Vol. II, No. 1. (Honolulu, 1906).

Stokes, John F. G., Note on Rear Admiral Rodman's article, *The Journal of the Polynesian Society*, Vol. 37, No. 1 (New Plymouth, N. Z. March, 1928).

Stokes, John F. G., "The Sacred Calabash", *United States Naval Institute Proceedings*, Vol. 54, No. 100, (Menasha Wisc., 1928).

Stubbs, William C. "Report on the Agricultural Resources and Capabilities of Hawaii", *United States Department of Agriculture Bulletin* 95 (Washington, 1901).

Te Rangi Hiroa (Peter H. Buck), "The Value of Tradition in Polynesian Research", *The Journal of the Polynesian Society* Vol. 35, No. 3 (New Plymouth, N.Z. September, 1926).

Te Rangi Hiroa (Peter H. Buck), *The Material Culture of the Cook Islands (Aitutaki)*. (New Plymouth, N. Z., 1927).

Te Rangi Hiroa (Peter H. Buck), "Samoan Material Culture", *Bernice P. Bishop Museum Bulletin* 75 (Honolulu, 1930).

Te Rangi Hiroa (Peter H. Buck), "Ethnology of Manihiki and Rakahanga", *Bernice P. Bishop Museum Bulletin* 99 (Honolulu, 1932a).

Te Rangi Hiroa (Peter H. Buck), "Ethnology of Tongareva", *Bernice P. Bishop Museum Bulletin* 92 (Honolulu, 1932b).

Te Rangi Hiroa (Peter H. Buck), "Ethnology of Mangareva", *Bernice P. Bishop Museum Bulletin* 157 (Honolulu, 1938a).

Te Rangi Hiroa (Peter H. Buck), *Vikings of the Sunrise* (New York 1938b).

Thomson, Arthur S., *The Story of New Zealand*, I - II, (London, 1859).

Thomson, William J., "Te Pito te Henua or Easter Island", *Report of the U.S. National Museum, Under the Direction of the Smithsonian Institution, for the Year Ending June 30, 1889.* (Washington, 1891).

Thrum, Thomas G., *More Hawaiian Folk Tales*, (Chicago, 1923).

Tregear, Edward, *The Maori-Polynesian Comparative Dictionary* (Wellington, 1891).

Tregear, Edward, *The Maori Race* (Wanganui, N.Z. 1904).

Westervelt, W. D. *Legends of Mavi – A Demi God of Polynesia and of His Mother Hira* (Honolulu, 1910).

Westervelt, *Legends of Gods and Ghosts* (Boston and London, 1915).

Wilder, Gerrit Parmile, "Flora of Rarotonga", *Bernice P. Bishop Museum Bulletin* 86 (Honolulu, 1931).

Winne, Jane Lathrop, "Music", *Ancient Hawaiian Civilization* (Honolulu, 1933).

Wise John H., "Food and its Preparation", *Ancient Hawaiian Civilization* (Honolulu, 1933a).

Wise, John H., "Medicine", *Ancient Hawaiian Civilization* (Honolulu, 1933b).

INDEX

Acculturation, 9
Agricultural and horticultural methods, 13-19
Aitutaki (see Cook Islands)
Archaeology, 94
Art medium, 69-78
Austral Islands, 3, 7, 21, 26, 32-33, 92
Bailers (see Use categories)
Bait containers (see Use categories)
Bamboo containers, 11, 22, 81
Basketwork on gourds, 34, 79
Bowls (see Use categories)
Calabash, 14
Canoes, 5
Chants, 15, 17-18, 54, 56, 58, 83, 89
Child in gourd, 85
Coconut containers, 11, 22, 82
Conclusions, 95-96
Containers, 21-37
Cook Islands, 3, 7, 13, 21, 26, 92-93
Covers (see Use categories)
Creation myths, 81
Cucurbita (see Genera)
Cultivation, 14-20
Culture, 8-9
Culture areas, 7
Cup and ball game (see Use categories)
Cups (see Use categories)
Customs, 8
Decoration, 69-78
 Types, 69-70
 Methods, 70-74
 Patterns, 74-78

Decoys (see Use categories)
Devination, 81-82
Designs (see Patterns)
Disc washers (see Use categories)
Dishes (see Use categories)
Drums (see Use categories)
Dye containers (see Use categories)
Easter Island, 3, 7, 19, 21, 26, 31, 35-36, 44, 59, 61, 66-67, 86-87, 93
Ecology, 12-13, 91
Economic importance, 91-96
Ellice Islands, 8, 91
Evil shut in a gourd, 2
Feather containers (see Use categories)
Feeding spirit familiars, 81-82
Figures, 8
Fire making (see Use categories)
Fishing equipment containers (see Use categories)
Fish line reels (see Use categories)
Floats (see Use categories)
Flutes derived from gourd form, 49
Folklore, 81-90
Food containers (see Use categories)
Food plants and animals, 4, 20
Funnels (see Use categories)
Futuna, Island of, 7
Game (kilu) (see Use categories)
Genera and varieties, 12-13
 Legenaria, 12
 Cucurbita, 12
 Ipu nui, 12-13
Ghost gourd, 82-83
Gourd as food, 20
Gourd for burying an egg (see Use categories)
Gourd for feeding fowl (see Use categories)
Gourd, natural enemies ,16

Index

Gourds, distribution, 11
Hawaiian Islands, 3, 7, 10, 12-13, 14, 19, 21-25, 27-30, 32-37, 39-40, 45-49, 56-63, 69-79, 81-87, 89-90, 93-95
Horticultural methods (see Agricultural)
Ipu nui (see Genera)
Islands, volcanic and coral, 4
Kilu (see Game)
Legenaria (see Genera)
Language, 8-9
Legends, 81-90
Lure (see Use categories)
Magic, agricultural, 14-18
Magic gourd, 85, 88-89
Mangareva, Island of, 3, 7, 91
Manihiki, Island of, 7
Manticism, 82-83
Maori (see New Zealand)
Marquesas Islands, 3, 7, 26, 27, 31, 65-66, 78, 82, 88-89, 92
Masks (see Use categories)
Migrations, 4-5
Mist imprisonment, 85
Mock spearheads (see Use categories)
Museum collections of gourds, 9
Musical instruments, 39-51
Myths, 81-90
Nettings, 78
New Zealand, 4, 7, 14, 25, 27-28, 30, 32-33, 42, 48, 55-56, 60, 63, 64, 67, 77-78, 79, 83, 89, 93
Niue, Island of, 8
Offering container (see Use categories)
Offerings, 81
Oil containers (see Use categories)
Origin myth, 86
Ornamentation (see Decoration)
Ossuary urn (see Use categories)
Paint containers (see Use categories)

Patterns (see Decoration)
Petroglyphs, 77
Platters (see Use categories)
Polynesia, geographical limits, 3-4
Pottery, lack of, 11
Prayers, 1-2
Preparation of gourds, 19
Presentation gifts, 94
Preserved food containers (see Use categories)
Proverbs, 90
Pukapuka, Island of, 8, 91
Punctured water gourd, 85
Pyrography, 69-70
Rakahanga, Island of, 8, 91
Rapa, Island of, 7
Rat guards (see Use categories)
Rattles (see Use categories)
Religion, 8, 81-89
Repairing, 74
Riddles, 90
Samoa Islands, 3, 21, 28, 82, 89, 91-92
Sayings, 90
Seamanship, 5-6
Social classes, 8
Society Islands, 3, 7, 21, 26, 28, 31, 47-48, 49, 82-83, 85-86, 89-90, 92
Soul imprisonment, 82-83
Sounding chambers (see Use categories)
Spinning rattles (see Use categories)
Spittoons (see Use categories)
Stopper of gourd a death omen, 73, 82
Strainers (see Use categories)
String figures, 89-90
Syringes (see Use categories)
Tahiti (see Society Islands)
Tales, 81-89

Index

Tapa containers, (see Use categories)
Toilet spatula (see Use categories)
Tokelau Islands, 8, 91
Tonga Islands, 3, 7, 21, 28, 89, 91
Tongareva, Island of, 8, 91
Tools, 8
Tops (see Use categories)
Toy spinning disc (see Use categories)
Toy water bottle (see Use categories)
Trumpet (see Use categories)
Trunks (see Use categories)
Tuamotu Archipelago, 3, 7, 85, 89-90
Tubuai (see Austral Islands)
Use categories, 21-67
 Bailers, 61
 Bait containers, 35
 Bowls, 21, 28-32, 69
 Covers, 37
 Cup and ball game, 47, 59
 Cups, 27-28
 Decoys, 60
 Disc washers, 66
 Dishes, 28-32
 Drums, 42-44, 70
 Dye containers, 36
 Feather containers, 34-35
 Fire making, 66
 Fish line reels, 60-61
 Fishing equipment containers, 35-36
 Floats, 60
 Food containers, 28-32
 Funnels, 61-62
 Game (kilu) 57-59, 75
 Gourd for burying an egg, 36
 Gourd for feeding fowl, 36
 Kilu (see game)

Lamps, 63
 Lure, 60
 Masks, 63
 Mock spearheads, 59, 87-88
 Offering containers, 36-37
 Oil containers, 28
 Ossuary urn, 37
 Paint containers, 36
 Platters, 32
 Preserved food containers, 32-33
 Rat guards, 65-66
 Rattles, 39-40, 75
 Sounding chambers, 44-45
 Spinning rattles, 40-42
 Spittoons, 37
 Strainers, 62
 Swing tops, 50-51
 Syringes, 61
 Tapa containers, 33-34
 Toilet spatula, 65
 Tops, 55-56
 Toy spinning disc, 56-57
 Toy water bottle, 57
 Trumpet, 48, 50
 Trunks, 29, 33-34
 Water bottles, 22-27, 69, 74-78
 Whistles, 45-48, 69-70, 64-65
 Writing medium, 66
Uvea, Island of, 7
Voyages, 4-7
Water bottles (see Use categories)
Whistles (see Use categories)
Wind imprisonment, 84
Wooden containers, 11, 35-36
Writing medium (see Use categories)

TABLE OF USE CATEGORIES

TABLE OF USE CATEGORIES

POLYNESIAN ISLANDS	Containers for Liquids						OTHER									CONTAINERS							
	1	2	3	4	5	6	7	8	9	10	11	12	13	14	15	16	17	18	19	20	21	22	
	WATER (HOUSEHOLD)	WATER (FIELD)	WATER (CANOE)	SEA WATER	CUP (WATER OR KAVA)	OIL	BOWLS & OPEN GOURDS FOR FOOD	COVERED GOURDS FOR FOOD	PLATTER	PRESERVING FOOD	BIRD PRESERVER (DUMBBELL-SHAPED)	TRUNK (TRAVELING)	TRUNK (STORAGE)	FEATHER	TAPA	FISHING EQUIPMENT	BAIT	BODY PAINT AND TATTOO DYE	FEEDING FOWL	BURYING AN EGG	OFFERINGS	OSSUARY URN	
HAWAIIAN	X	X	X	X	X		X	X	X			X	X	X	X	X	X	X				X	X
NEW ZEALAND	X				X	X			X	X													
MARQUESAS	X							X													X		
EASTER	X				X		X						X	X	X			X	X	X			
SOCIETY	X			X	X	X	X																
COOK	X																						
AUSTRAL	X		X				X	X	X	X													
SAMOA	X					X																	
TONGA						X																	

Musical Instruments Toys

	27	28	29	30	31	32	33	34	35	36	37	38	39	40	41	42	43	44	45	46	47	48	49	50	51	52	53
	DRUM	SOUNDING CHAMBER	WHISTLE	TRUMPET	SWING TOP	HUMMING TOP	SPINNING DISC	TOY WATER BOTTLE	GAME (KILU)	CUP AND BALL GAME	MOCK SPEARHEAD	FLOAT	DECOY	LURE	FISH LINE REEL	BAILER, CANOE	SYRINGE	FUNNEL	STRAINER	LAMP	MASK	TOILET SPATULA	RAT GUARD	DISC WASHER	FIRE MAKING	MEDIUM FOR INSCRIPTIONS	NAVIGATING INSTRUMENT
	X		X		X		X	X	X	X		X	X	X	X	X	X	X	X	X	X	X	X	X	X		X
			X	X		X						X									X				X		
		X									X					X									X		

PLATE I

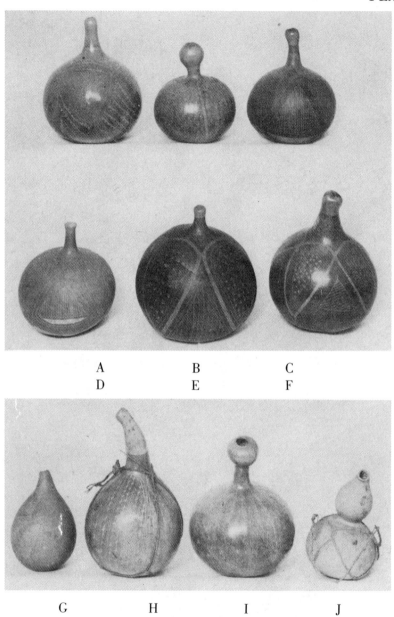

A B C
D E F

G H I J

HAWAIIAN WATER BOTTLES
(Courtesy of the Peabody Museum of Salem)

PLATE I

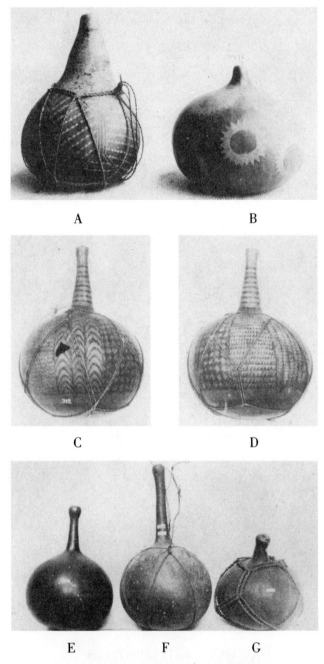

A B

C D

E F G

HAWAIIAN WATER BOTTLES
(A, B, E, F, G: Courtesy of the Bernice P. Bishop Museum C, D: Courtesy of the Peabody Museum, Harvard University)

PLATE III

A B C

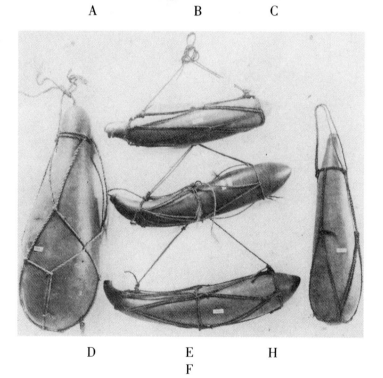

D E H
 F
 G

HAWAIIAN WATER BOTTLES
(Upper: Courtesy of the Peabody Museum of Salem Lower: Courtesy of the Bernice P. Bishop Museum)

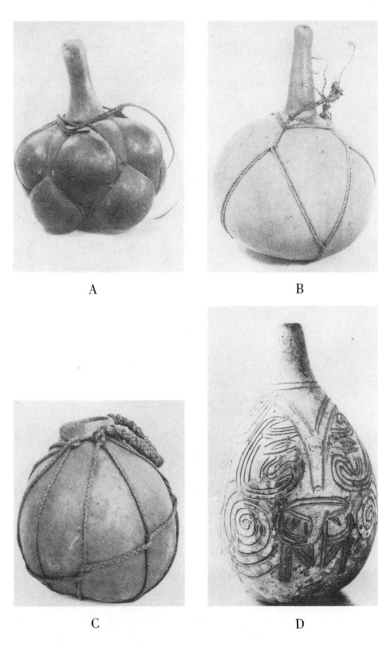

POLYNESIAN WATER BOTTLES

(A, C: Courtesy of the Bernice P. Bishop Museum B: Courtesy of the Peabody Museum of Salem D: Courtesy of the Canterbury Museum)

PLATE V

A

B

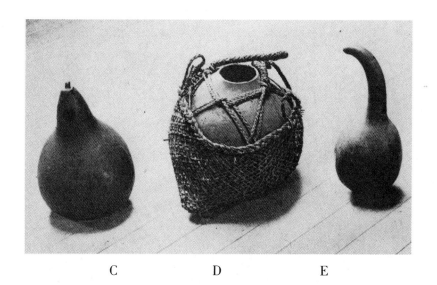

C D E

NEW ZEALAND WATER BOTTLES AND CONTAINERS

*(A, B: Courtesy of the Dominion Museum
Lower: Courtesy of the Canterbury Museum)*

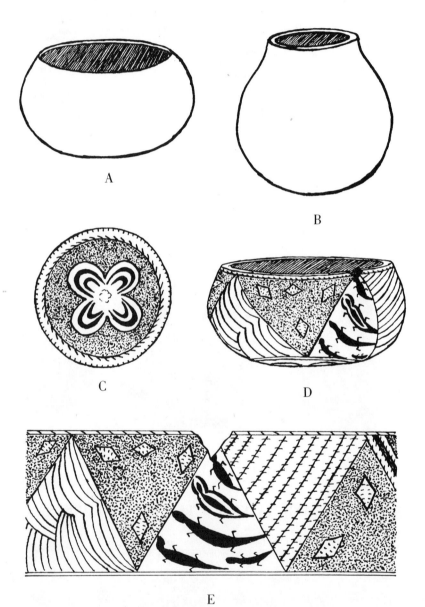

E
HAWAIIAN CUPS

PLATE VII

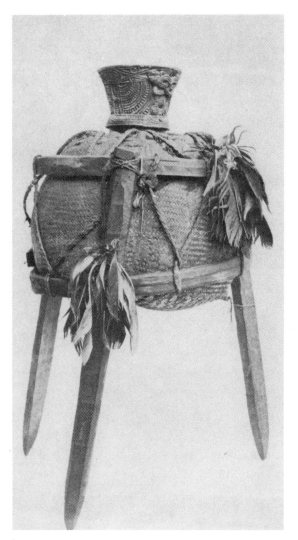

NEW ZEALAND GOURD FOR PRESERVING BIRDS
(Courtesy of the Bernice P. Bishop Museum)

PLATE VII

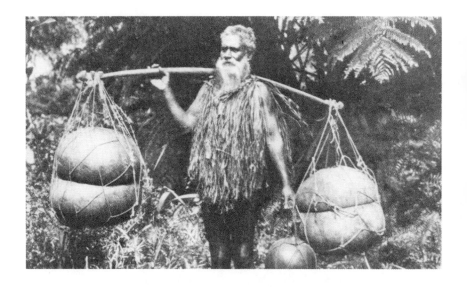

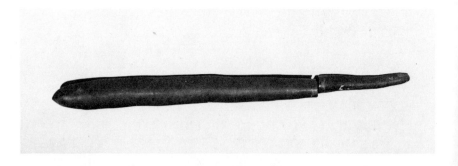

Upper: Hawaiian method of carrying large gourd containers
Lower: Alleged gourd lovers whistle, 51.5 inches long (P.M.S. 54,414) Collectd by early 19th century missionaries.

PLATE IX

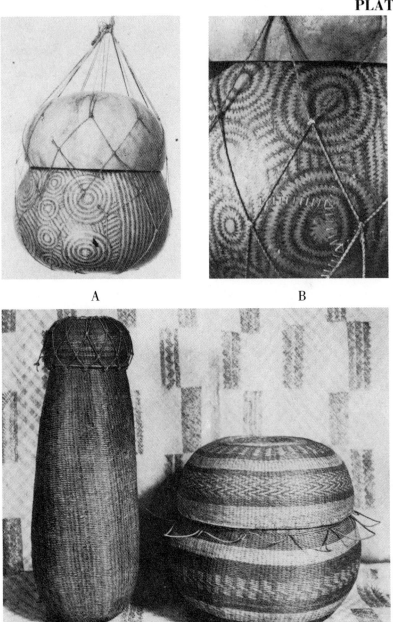

A and B: GOURD TRUNK AND DETAIL OF THE DESIGN.
(Courtesy of the Peabody Museum, Harvard University)
C and D: GOURDS COVERED WITH BASKETRY
(Courtesy of the Peabody Museum of Salem)

PLATE

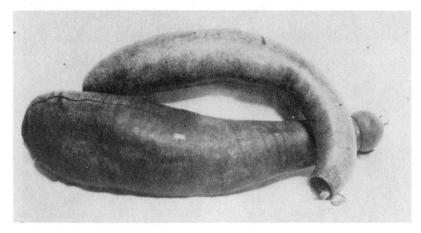

A B

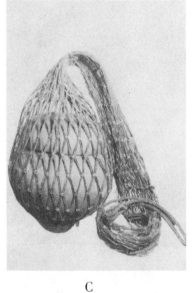

C D

HAWAIIAN CONTAINERS

*(A, B: Courtesy of the Bernice P. Bishop Museum
C, D: Courtesy of the Peabody Museum of Salem)*

PLATE XI

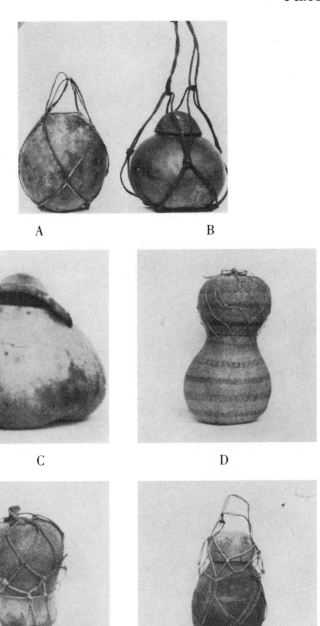

A and B: MARQUESAN CONTAINERS
C to F: HAWAIIAN CONTAINERS
(Courtesy of the Bernice P. Bishop Museum)

PLATE X

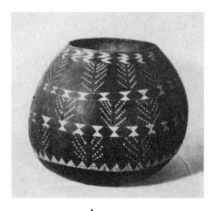
A

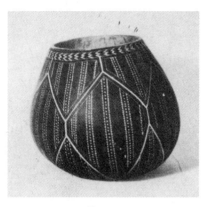
B

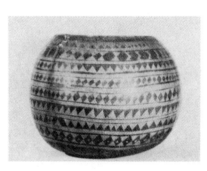
C

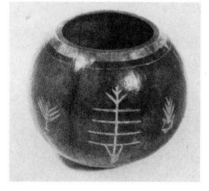
D

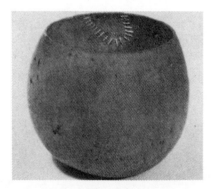
E

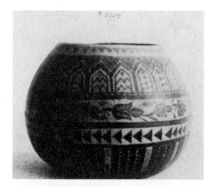
F

HAWAIIAN BOWLS
(A, B and F: Courtesy of the Bernice P. Bishop Museum
C: Courtesy of the Peabody Museum, Harvard University
D, E: Courtesy of the Peabody Museum of Salem)

PLATE XIII

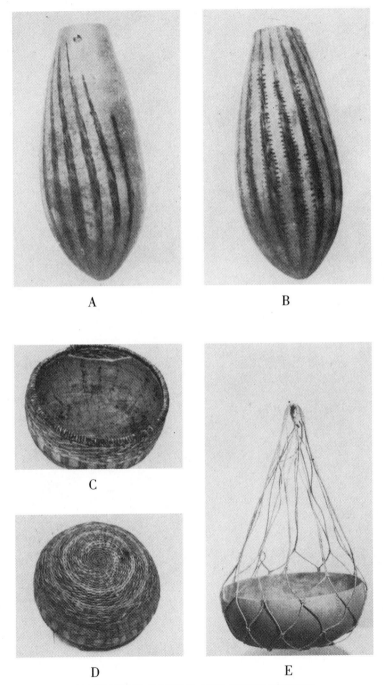

HAWAIIAN BOWLS AND CONTAINERS
*(A to D: Courtesy of the Peabody Museum, Harvard University
E: Courtesy of the Peabody Museum of Salem)*

PLATE XI

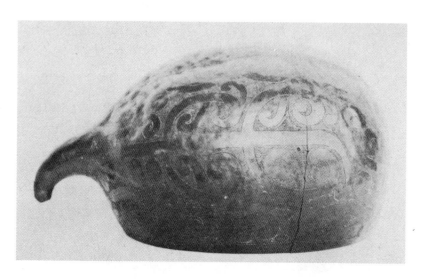

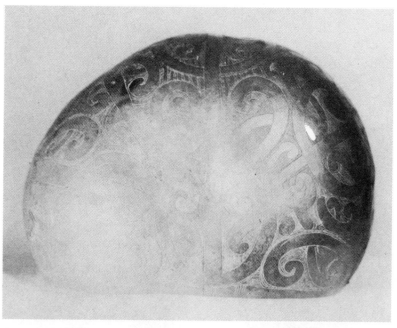

NEW ZEALAND BOWLS
*(Upper: Courtesy of the Bernice P. Bishop Museum
Lower: Courtesy of the Dominion Museum)*

PLATE XV

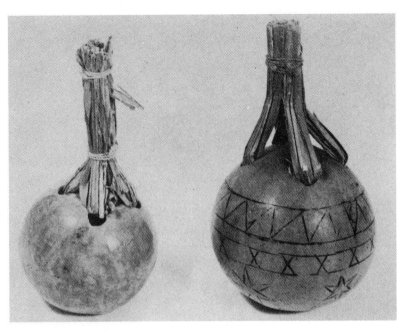

A B

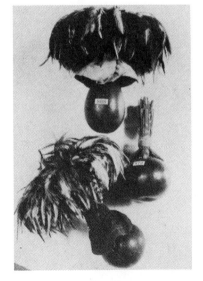

C E
D

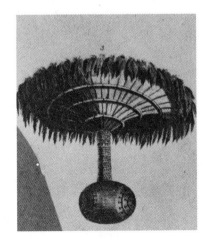

F

HAWAIIAN RATTLES
*(A and B: Courtesy of the Peabody Museum of Salem
C to F: Courtesy of the Bernice P. Bishop Museum)*

PLATE XV

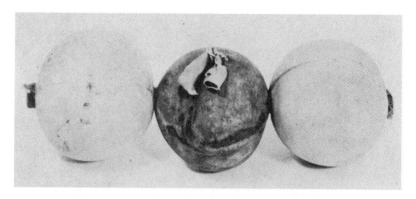

A

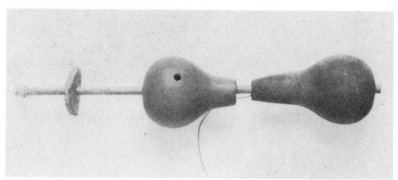

B

C

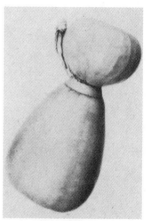

D

HAWAIIAN RATTLES AND DRUMS
*(A and B: Courtesy of the Peabody Museum of Salem
C and D: Drums, Courtesy of the Peabody Museum, Harvard University)*

PLATE XVII

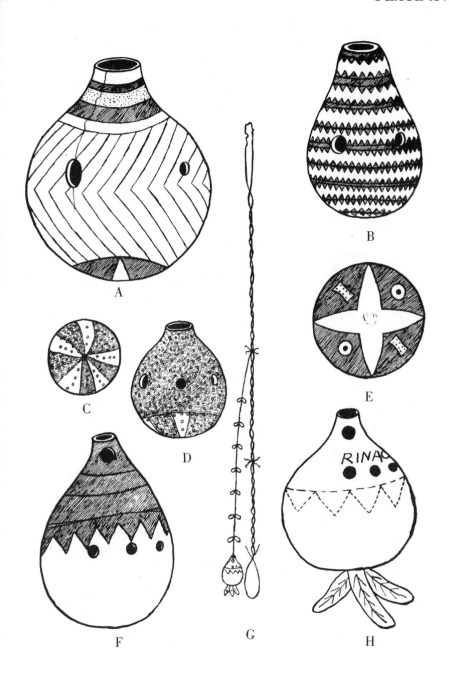

HAWAIIAN WHISTLES

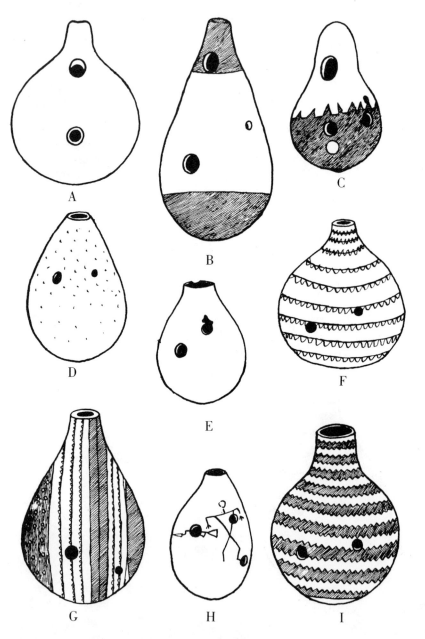

PLATE XVII

HAWAIIAN WHISTLES

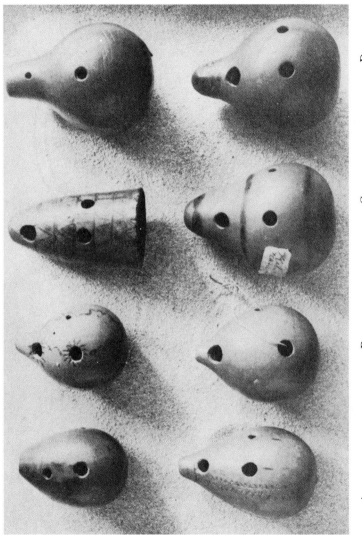

A B C D
E F G H

HAWAIIAN WHISTLES
(Courtesy of the Bernice P. Bishop Museum)

PLATE XIX

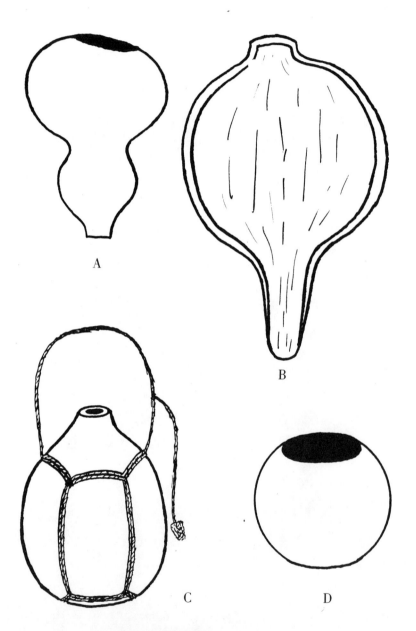

A and B: FUNNELS
C: AUSTRAL ISLANDS WATER BOTTLE
D: EASTER ISLAND CUP

PLATE XXI

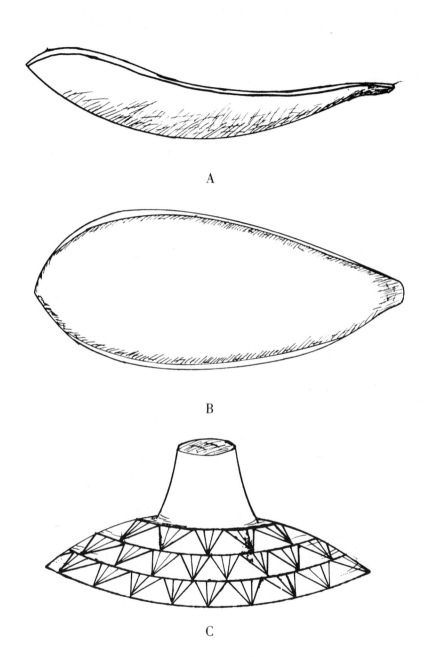

A and B: Platter C: *KILU*

PLATE XXII

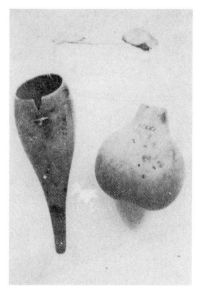

A

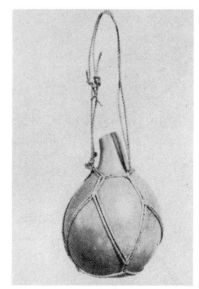

B

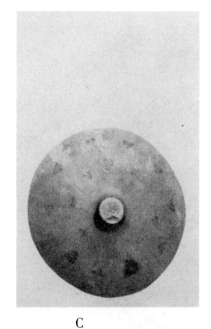

C

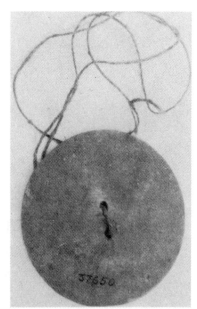

D

A: SYRINGE AND CONTAINER
B: TOY WATER BOTTLE
C: TOY NOISE MAKER
D: *KILU*

(A and D: Peabody Museum, Harvard University
B and C: Peabody Museum of Salem)

PLATE XXIII

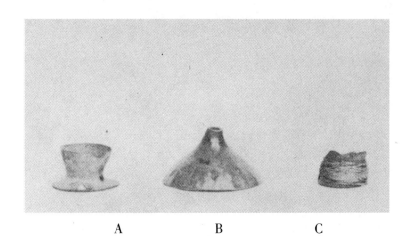

A B C

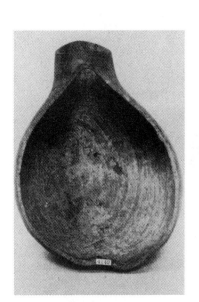
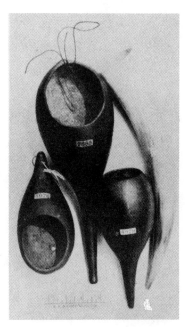

D E F G H

A and C: FISH LINE REELS
B: KILU
D: STRAINER
E to H: SYRINGE

(Courtesy of the Bernice P. Bishop Museum)

PLATE XXIV

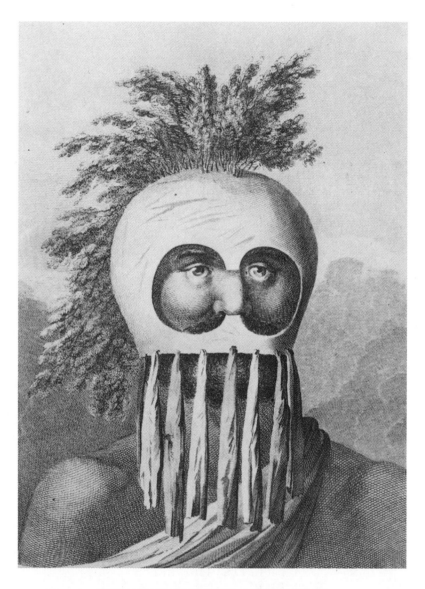

HAWAIIAN WEARING GOURD MASK
From Cook's third voyage, Plate 66

PLATE XXV

HAWAIIANS WEARING GOURD MASKS
From Cook's third voyage, Plate 65

PLATE XXVI

DESIGNS ON THE BOTTOMS OF WATER BOTTLES

PLATE XXVII

DESIGNS ON THE BOTTOMS OF WATER BOTTLES

PLATE XXVIII

DESIGNS ON THE BOTTOMS OF WATER BOTTLES

PLATE XXIX

DESIGNS AROUND THE NECKS OF WATER BOTTLES

DESIGNS ON THE SIDES OF WATER BOTTLES

DESIGNS ON THE SIDES OF WATER BOTTLES

PLATE XXXII

DESIGNS ON THE SIDES OF WATER BOTTLES

PLATE XXXIII

DESIGNS ON HAWAIIAN GOURDS

DESIGNS ON HAWAIIAN GOURDS